Wildlife
Photographer of the Year
2015 Highlights

Published by the Natural History Museum, London

First published by the Natural History Museum, Cromwell Road, London SW7 5BD
© The Trustees of the Natural History Museum, London, 2015
Photography © the individual photographers 2015

ISBN 978 0 565 0 93969

A catalogue record for this book is available from the British Library.

10 9 8 7 6 5 4 3 2 1

Competition and winners captions editor: Rosamund Kidman Cox
Winners caption writers: Tamsin Constable and Jane Wisbey
Designer: Bobby Birchall, Bobby&Co Design
Colour reproduction: Saxon Digital Services UK
Printing: Printer Trento Srl, Italy

Front cover: Two fox cubs and mother, Grand Teton National Park, Wyoming, USA
© Ashleigh Scully.

Contents

Foreword

The Wildlife Photographer of the Year Competition is, quite simply, wonderful.

This is not flattery. It is a statement of fact. Who can argue that these awards showcase images that are not full of wonders? These are photographs that make us wonder anew at the world about us. The word 'wonder' captures the results of a process that starts with more than 40,000 photographs being entered for the competition. The process ends with, perhaps, more than a million people visiting the exhibition to contemplate the one in 400 images or less that made it through stringent rounds of judging to be anointed as a winner.

And what is it that the entrants compete for and then we all want to see? It is to be recognized as having recorded a wonder of the natural world with a quality that rises above so many others. For the judges, the task is to sift out the truly distinguished from all those other thousands of valiant efforts that are not quite distinct enough.

There is no easy formula for what it takes to be a winner. But there are common points between the images that make the final selection. All the images contain a vital and distinctive blend of insightful observation of wildlife and photographic skill. Both factors are needed in some strength to pass through the various rounds of judging. With the very best images that have insight and skill, the ingredients of luck and inspiration are added. Being in the right place at the right time, and taking the right action to shoot a great image at that point, is something that only happens to even the greatest photographers on the best (and sometimes the worst) of days.

Consider the Wildlife Photographer of the Year 2015 award for the image of a red fox that has killed an Arctic fox. This photograph encompasses several elements which, combined, commend it highly. It captures in clinical and meditative detail a key behaviour. And at the same time, crucially, it does this with a striking composition – which is an unpredictable result of animal behaviour combined with photographer behaviour. There is a strange, even poetic, grace in the bloody subject, delivered by the choice of an unusual moment where it is as if one fox has taken off the coat of the other, or as if one is the ghost-shadow of the other, a death foretold as well as a death executed. The image resonates with ambiguity that raises it to the level of art, but not at the expense of working as a precise documentation of an event. As an afterthought, aftershock even, the image also has a powerful topical message in presenting a behaviour that may be increasingly common as red foxes encroach on Arctic fox territory.

Great wildlife images are not made but neither do they just happen. While they don't set out to be art, but rather focus on being a powerful document, the best, most definitely, are highly artistic works. They meet one resonant definition of art, which is that art 'makes the familiar strange'. As a result, a photograph of a familiar fox in an unusual setting of a bland icy waste, can open up a powerful meditation on life and death. What many remarkable wildlife photographs also do is the converse – they make the strange familiar. We see an image of a creature or a behaviour that we have never seen before, and after the encounter the image is seared upon our understanding of the living world. This fox image unnerves us with its speculation on the shifting relationship between members of the same family encroaching on each other's territories.

If there was one theme from the judging this year that I would like to highlight it is that the jury was struck by the strong work exploring wildlife in urban situations. Photographers are now increasingly exploring this vital subject, and it is perhaps a manifestation of our time where the majority of us now live in urban environments. What this means for our wildlife is profound and troubling. We may wonder that what lies ahead may alarm more than delight. It is the power of the Wildlife Photographer of the Year Competition that delivers innocent pleasure whilst drawing attention to preservation and conservation issues. Please enjoy and respond.

Lewis Blackwell, chair of the jury, 2015

The Competition

For half a century, the Wildlife Photographer of the Year Competition has showcased the best in wildlife photography – indeed, has both charted and changed the development of wildlife photography itself. The photographers who have featured in it have included both the leading professionals of the day and talented amateurs. Today it remains the world's largest and most prestigious competition championing images of nature and natural environments.

Over the years, the increase in number of entries has paralleled the increase in photographers and accessibility of equipment but also, most notably, the growth in digital photography in the past decade, resulting in an annual entry now exceeding 40,000. An international panel of judges selects the final 100 entries from a range of categories encompassing all aspects of wildlife and environmental photography, with separate categories for young photographers.

No manipulation of photographs is allowed beyond in-camera settings and digital processing according to strict rules. Subjects must be wild and photographed in the wild, unless the picture is meant to illustrate an ethical or conservation issue. Just as important is the welfare of the animal subjects, and their manipulation for photography is strictly forbidden. The overall aim is to keep the artistry to different ways of seeing nature and to show only pictures that are truthful to nature.

All of the photographers share a passion for the natural world. Through the exposure of their work to an audience of many millions, the competition provides a showcase for both established and developing talent and an inspiration to photographers starting out. But it also serves to inspire an audience of many millions to marvel at and value the importance of the truly glorious nature of life on Earth.

The call for entries for next year's competition runs from December 2015 to February 2016.

Find out more at www.wildlifephotographeroftheyear.com

Judges

Sandra Bartocha (Germany), nature and fine art photographer

Stella Cha (USA), creative director, The Nature Conservancy

Paul Harcourt Davies (Italy), nature photographer and author

Kazuko Sekiji (Japan), curator, Tokyo Metropolitan Museum of Photography

Thomas D Mangelsen (USA), photographer

Kathy Moran (USA), senior editor for natural history, *National Geographic* Magazine

Dr Alexander Mustard (UK), underwater photographer

Thierry Vezon (France), nature photographer

CHAIR

Lewis Blackwell (UK), author and creative director

The Wildlife Photographer of the Year 2015

The Wildlife Photographer of the Year 2015 is **Don Gutoski**, whose picture has been chosen as the most striking and memorable of all the entries in the competition.

A tale of two foxes

Don Gutoski

CANADA

From a distance, Don could see that the fox was chasing something across the snow. As he got closer, he realized it was an Arctic fox, and by the time he was close enough to take photographs, the smaller fox was dead. Don watched for three hours from the tundra buggy as the red fox fed on the carcass. The light was very low, and it was −30˚C (−22˚F), which meant Don needed to keep both the camera and his fingers from freezing. Finally, having eaten its fill, there was a moment when the fox paused to regrip the skin before starting to drag away the remains to cache for later. It was then that Don took his winning shot. The drama was enacted in Wapusk National Park, near Cape Churchill in Canada. Increasing temperatures in the Arctic have allowed the range of the red fox to extend northward. Both species of fox hunt small rodents, in particular lemmings, but where the ranges overlap, the red fox has been recorded as a predator of Arctic foxes as well as a competitor for food. But few actual kills by red foxes have been witnessed, probably because the two species normally avoid each other. As climate change causes the tundra to warm and allows the red fox to move further north, it's likely that conflicts between the two will become more common.

Canon 1DX + 200–400mm f4 lens + 1.4x extender at 784mm; 1/1000 sec at f8; ISO 640.

Don Gutoski

Brought up in the Canadian countryside, Don has had a passion for wildlife and photography since he was a teenager. Though he works as an emergency-ward doctor, he spends all his spare time photographing wildlife, in particular animal behaviour, both in wilderness regions of Canada and overseas. He lives in southern Ontario, surrounded by the 40-hectare (100-acre) wildlife reserve that he's created.

'What might simply be a straightforward interaction between predator and prey, struck the jury as a stark example of climate change, with red foxes encroaching on Arctic fox territory. This image is graphic, it captures behaviour and it is one of the strongest, single storytelling photographs I have ever seen.'
Kathy Moran

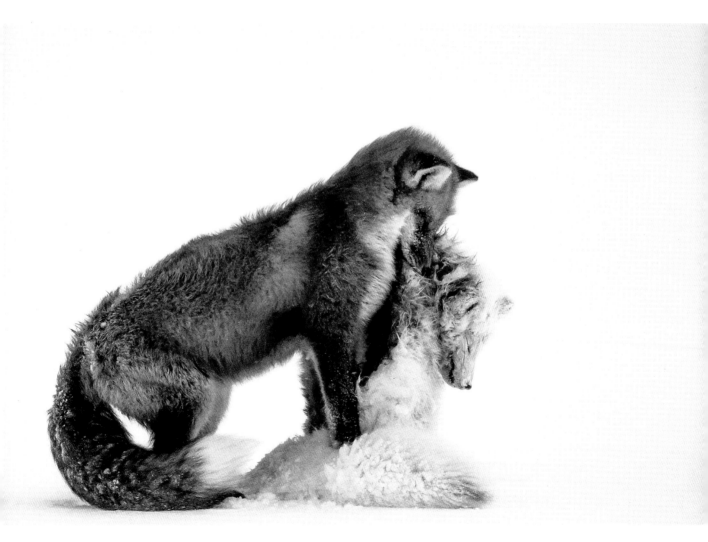

The Portfolio Award

This award portrays the breadth of the photographer's skill, whilst illustrating the passion, dedication and expertise needed to create a consistent collection of captivating images.

By the light of the moon

Audun Rikardsen

NORWAY

At night, in a scene lit by the moon and the northern lights, a brown trout hangs in the shallows of a river in northern Norway. After spending the summer at sea, it has returned in late autumn to spawn in the river where it hatched. The trout gathering in the upper reaches create nests in the gravel into which they release their sperm and eggs. They often do this at night to avoid predators such as eagles, which may gather along the banks to feast on the migrating fish. Audun had worked on this river for several years and knows it intimately – exactly when the fish congregate and which bends of the river they favour. He also knows how they behave and how to approach without scaring them. But the technical challenges of the shot involved several months of planning and the design of a special housing and underwater flash set-up, as well as a system that would allow him to alter the focus and aperture within a single exposure. That he got the image exactly as he visualized it was a dream come true.

Canon EOS-1D X + Samyang 14mm f2.8 lens; 35 sec at f22 and at f5.6; ISO 640; x2 Canon 600 strobes; home-made underwater housing.

'Innovations such as this portfolio come from knowledge about
the species, thoughtful preparation and visual anticipation, plus
the latest camera technology. These elements showcase nature
as we haven't seen it before.'

Sandra Bartocha

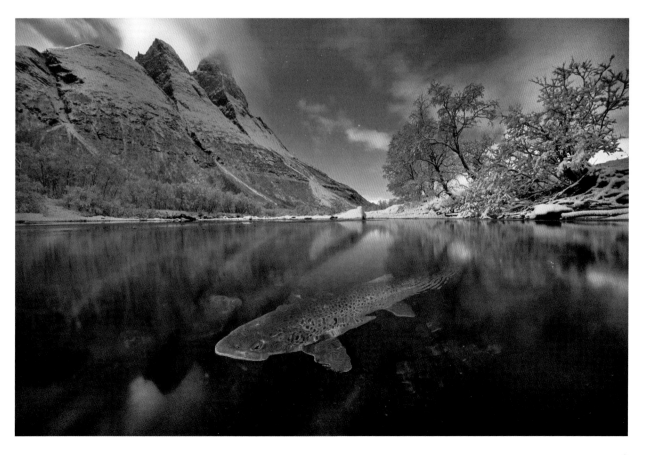

Alexander Mustard

Dark dive

In recent years, herring shoals have started to overwinter in a fjord near Tromsø in northern Norway. And where they go, humpbacks follow. They hunt herrings by corralling them against the surface and taking huge mouthfuls out of the swirling shoal. Audun's house is near the sea, and in winter he falls asleep to the sound of humpback blows as they surface to breathe. This picture was taken on a mid-December afternoon, the darkest time of the year. He had located the feeding group by listening for their blows and watching for their pale tail flukes. To illuminate the scene against the mountain backdrop, Audun had designed a system involving a powerful torch attached to the camera as well as flashes. Here one giant dives, exposing the unique 'fingerprint' pattern on its flukes. The great blows of two other whales are also illuminated as they surface just behind.

Canon EOS-1D X + Tamron 70–200mm f2.8 lens at 70mm; 1/250 sec at f3.5; ISO 2000; x2 Canon 600 flashes; 3200 lumen LED torch.

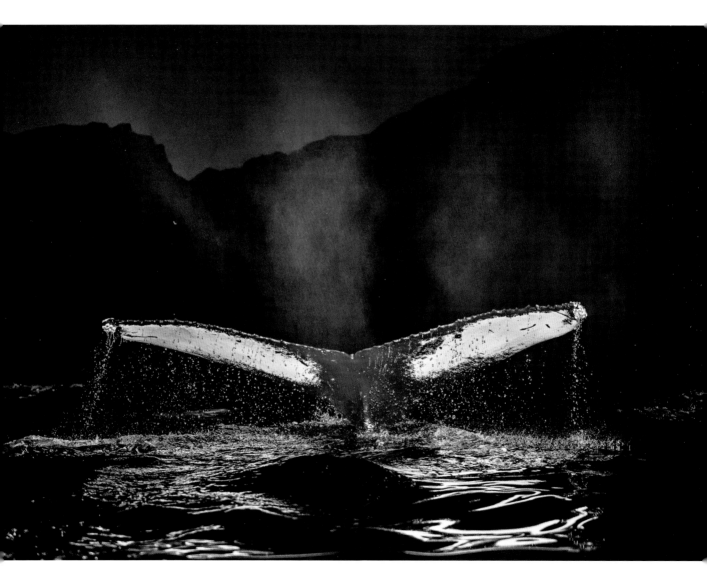

The last rays

In the water, Audun could hear the killer whales calling to each
other as they herded up a shoal of herrings. It was mid-November,
and the herrings had migrated into a fjord near Tromsø, pursued
by the whales. The sun was just on the horizon, striking the waves
at an angle so that the light cracked through the surface. It was
the time Audun had been waiting for. With his camera extended
on a pole, the settings pre-adjusted, he was ready. The moment
came when the lead male approached to check him out, moved
slowly past and then turned, angled towards the light, and took
a breath. 'It was a few magical seconds when everything fell into
place.' The next day, the sun finally dropped below the horizon,
not to reappear above the mountains until February.

**Canon EOS 5D Mark III + 16–35 mm f2.8 lens + ND 0.6 graduated filter;
1/200 sec at f6.3, ISO 2000; Aquatech housing.**

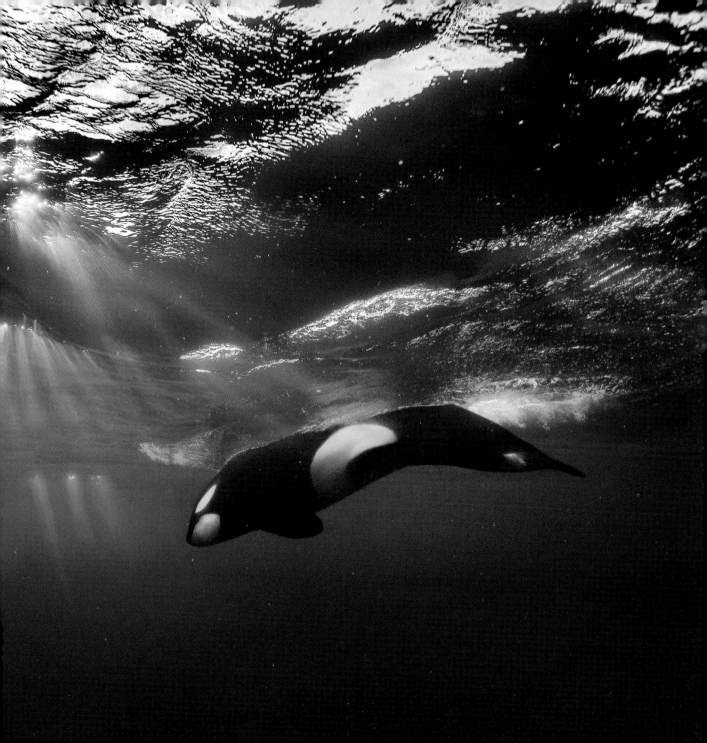

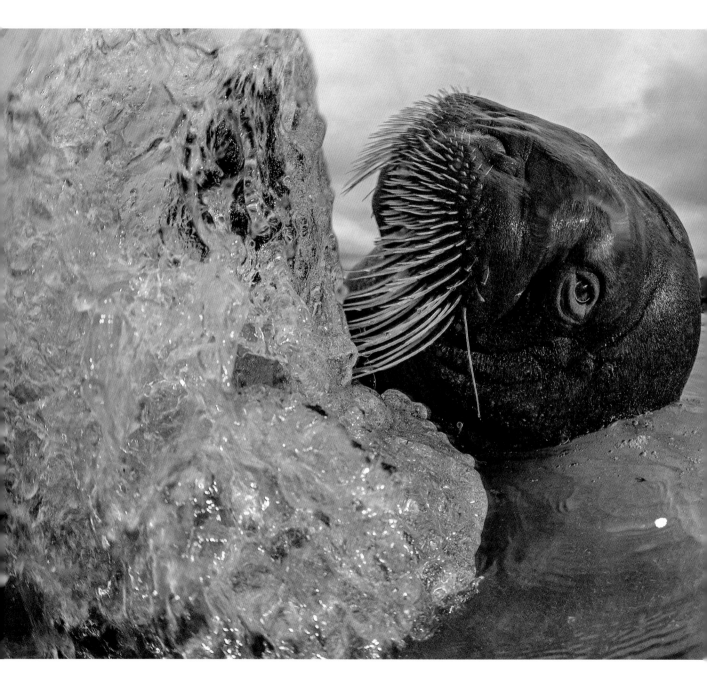

Splash-time with Buddy

Audun had mixed feelings about Buddy. Partly, he hoped that this young male walrus would stop hanging around the remote beach off Tromsø and join its kin farther north. The first two weeks after he and his friends found him they kept their distance, but their relationship really began one day when the walrus approached Audun, who was lying in the shallow water, and began to gently stroke his hand with his sensitive whiskers. For one-and-a-half months, Audun visited him regularly. 'I got to know his personality. He would talk to me, and I could tell whether he was grumpy or if he was having fun, teasing me by splashing water at me, as he's doing here on a midnight summer swim – the last time I ever saw him. Once, he put one flipper around one of my legs, hooked his tusks around the other leg, and tried to drag me out to play in deeper water.' Buddy did eventually leave, on the day Audun returned from a month's field trip, half an hour too late to see him for the last time. 'I still miss him,' says Audun.

Canon EOS 5D Mark III + 8–15mm f4 lens at 15mm; 1/160 sec at f10; ISO 2500; Canon 600 flash; Aquatech housing.

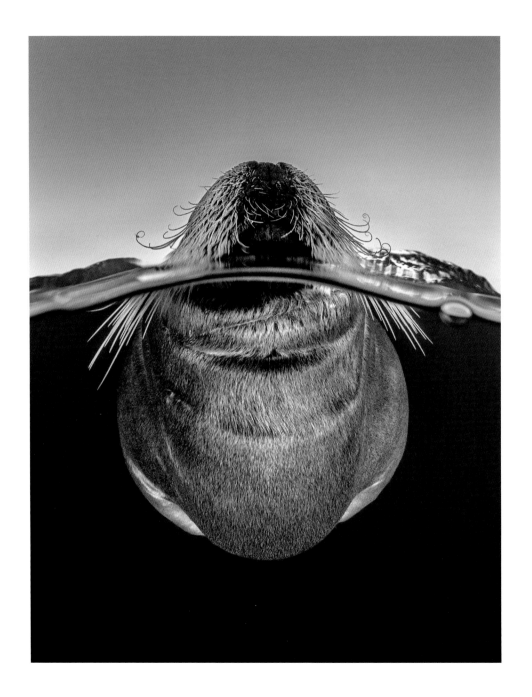

Deep sleeper

It was 1am but midsummer in northern Norway when Audun launched his dinghy to investigate something bobbing around in a fjord outside Tromsø. He found a bearded seal, from the Arctic, fast asleep, its throat puffed up with air and its flippers tucked in. It must have been asleep for a while because its whiskers above the surface had dried into curls.

Canon EOS 5D Mark III + 8–15mm f4 lens; 1/160 sec at f10; ISO 1000; Canon 600 flash; Aquatech housing.

Sea eagle snatch

When young, Audun spent many years ringing white-tailed sea eagles on the coast of northern Norway. Watching them snatch fish from the sea surface, he fantasized about what this might look like from below. After years of perfecting the technique, Audun eventually managed to photograph the millisecond moment, with water cascading off the fish as it was grabbed from above.

Canon EOS 5D Mark III + 8–15mm f4 lens at 15mm; 1/2500 sec at f8; ISO 2000; underwater housing + specially designed remote control.

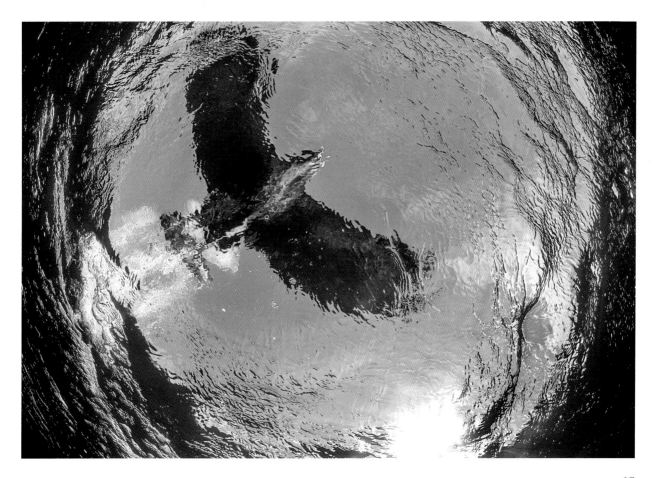

Earth's Diversity

The categories in this section focus on behaviour, action or portraits, depicting a sense of character, intimacy or uniqueness.

The heart of the swamp

Georg Popp
AUSTRIA

The morning sun filters through mist and the thick drapes of Spanish moss that festoon a dense stand of 1,000-year-old bald cypress trees in Louisiana's Atchafalaya Basin. It's one of the last remaining old-growth cypress stands in the USA, representative of how the swamps of the 'deep south' used to look. Where the buttresses emerge from the surface, they are 2–5 metres (7–16 feet) in diameter and wider still below water. The only way to reach the heart of the forest is by kayak – a two-hour trip. The water is too deep and dangerous to wade through, but near a tree buttress it's possible to stand in hip-high waders and rest a tripod on one of the many aerial roots. Having located in daylight the ideal spot for an image, Georg pinpointed it with a GPS device and then, using a head torch, paddled into the swamp in the dark and waited for dawn. His aim was to recreate the mystical, eerie atmosphere in the heart of the ancient swamp forest, something few have experienced. As dawn broke, the cypress stand came alive with the sounds and movements of an abundance of creatures – alligators, turtles, amphibians and countless birds, including bald eagles and osprey – 'a magical experience,' says Georg. Bald cypress evolved to live with naturally fluctuating water levels. Today, though, levees and dams keep the water at a constant level in this part of the basin. The soil never drains, and so the cypress seeds can no longer germinate.

Nikon D810 + 70–200mm f2.8 lens at 170mm; 1/320 sec at f8; ISO 200; Gitzo tripod.

'Dark and moody, what a brilliant backlit scene of another world. The sparkle on the water, light in a tunnel of trees, and I am pulled into a fairy tale.'

Sandra Bartocha

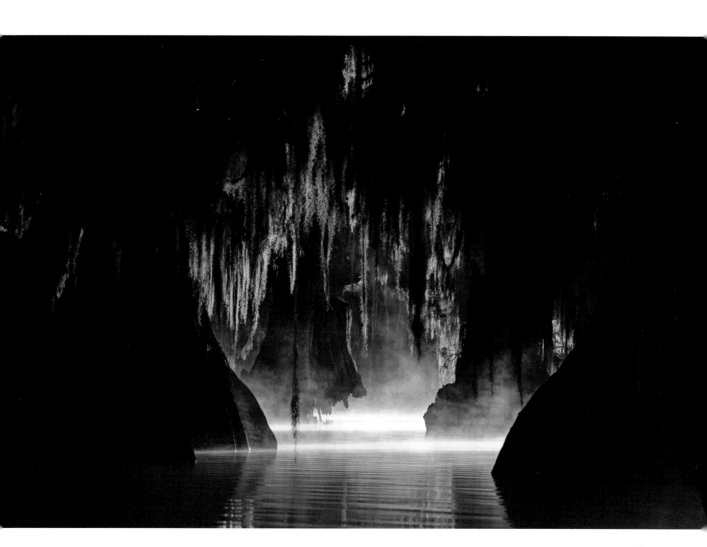

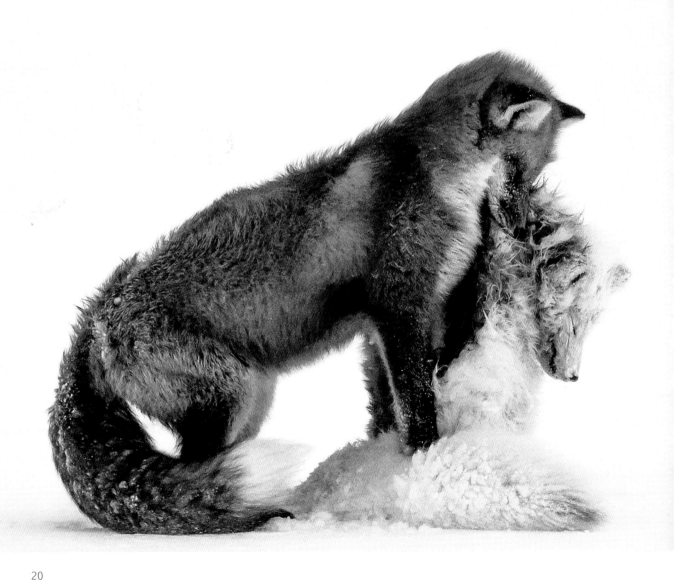

'The way the heads line up here, the curl of the red tail and the puddle of white fur, create a graphically intimate moment.'
Kathy Moran

A tale of two foxes

Don Gutoski

CANADA

It's a frozen moment revealing a surprising behaviour, witnessed in Wapusk National Park, on Hudson Bay, Canada, in early winter. Red foxes don't actively hunt Arctic foxes, but where the ranges of two predators overlap, there can be conflict. In this case, it led to a deadly attack. Though the light was poor, the snow-covered tundra provided the backdrop for the moment that the red fox paused with the smaller fox in its mouth in a grim pose.

Canon EOS 1D X + 200–400mm f4 lens + 1.4x extender at 784mm; 1/1000 sec at f8; ISO 640.

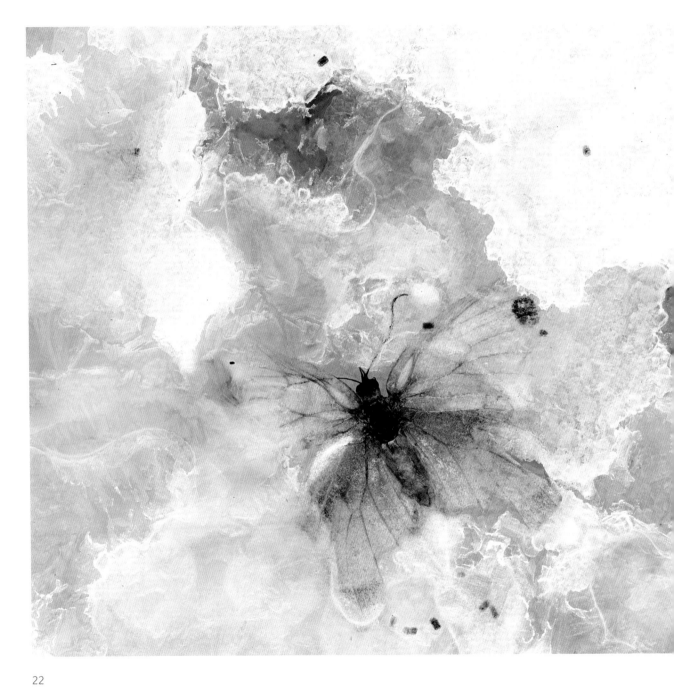

'The delicate harmony of the pastel colours renders a very pure atmosphere. However, the originality here is of having chosen a still life for a wildlife award. This butterfly captured in salt crystals symbolizes the fragile balance between life and death and our fleeting passage on Earth.'

Thierry Vezon

Butterfly in crystal

Ugo Mellone

ITALY

In the rocky crevices along the coast of Salento, layers of salt build up as seawater spray from storms evaporates under the strong summer sun. Ugo grew up in this region of Italy and takes many landscape images along the last stretch of the coast that remains wild and pristine. But he also keeps watch for the little details that tell stories and the miniature landscapes to be found among the rocks and in the limestone cliffs. He always finds something to inspire him. On this exploration, what caught his eye was the splash of orange in a solid salt pool. It was a female southern gatekeeper that had become mummified by the saltwater and entombed in a coffin of salt crystals. Most of her wing scales had gone, perhaps as she fluttered to try to escape, but her characteristic eyespots were still visible.

Canon EOS 7D + 100mm f2.8 lens; 1/10 sec at f11; ISO 100.

Still life

Edwin Giesbers

THE NETHERLANDS

A great crested newt hangs motionless near the surface of the stream. Also motionless in the water, in Gelderland in the Netherlands, was Edwin in a wetsuit. He had very slowly moved his compact camera right under the newt, and though he knew the shot he wanted, he had to guess at the framing and literally point and shoot. The male had just taken a breath and was possibly warming up at the surface. It was a cold April morning, and the trees were not yet in leaf, but it was mating time for these large newts, and the males were already on the lookout for females. Edwin took this shot as part of a major story on the threat facing amphibians throughout the Netherlands and Belgium: an Asian skin fungus similar to the one that has annihilated frogs and toads worldwide and has all but wiped out fire salamanders in the Netherlands. Scientists are bracing themselves for a collapse of European amphibian populations, unless some way is found to stop the fungus from spreading.

Canon G15 + 28-140mm f1.8–2.8 lens at 28mm; 1/500 sec at f6.3; ISO 200; Canon housing.

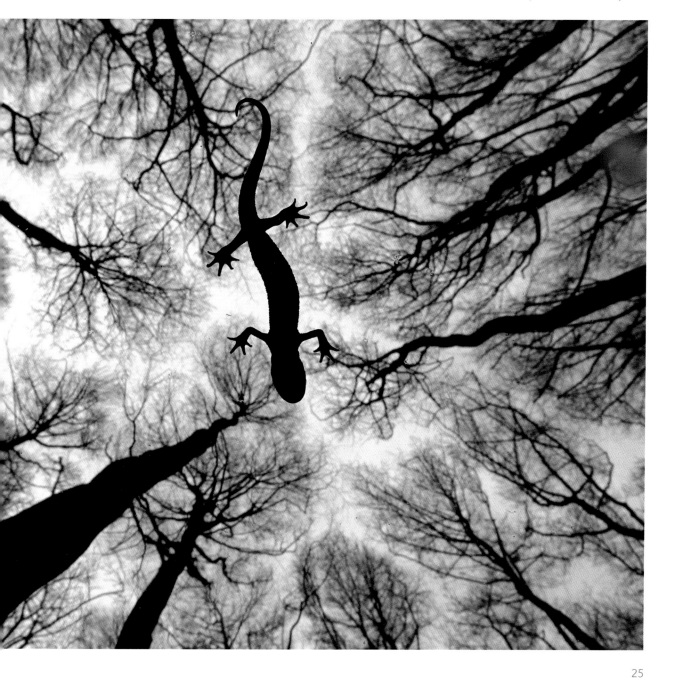

'This image stood out for me from the early stages of selection
because of its timelessness – it harks back to the glory days of
bird illustration by the likes of John James Audubon. It has action,
composition and is technically superb, from the soft background
that accentuates the subject to the sharpness of the protagonists.
There is remarkable control of the depth of field that sees all
three birds in pin-sharp focus.'
Paul Harcourt Davies

The company of three

Amir Ben-Dov

ISRAEL

Red-footed falcons are social birds, migrating in large flocks from
central and eastern Europe to southern and southwestern Africa.
The closest relationships seem to be pairs or parents with first-year
chicks, but otherwise, they maintain a degree of personal space.
But these three red-footed falcons were different. Amir spent six
days watching them on agricultural land near Beit Shemesh, Israel,
where their flock was resting on autumn migration, refuelling
on insects. What fascinated him was the fact that two subadult
females and the full-grown, slate-grey male were spending most
of their time together, the two females often in close physical
contact, preening and touching each other. They would also hunt
together from a post rather than using the more normal hovering
technique. As so often happens in photography, it was on the last
day in the last hour before he had to return home when the magic
happened. The sun came out, the three birds perched together,
and a subtle interaction took place: one female nudged the male
with her talon as she flew up to make space on the branch for the
other female. Exactly what the relationship was between the three
birds remains a mystery.

Canon EOS-1D X + 500mm f4 lens; 1/1600 sec at f8 (+0.33 e/v); ISO 500.

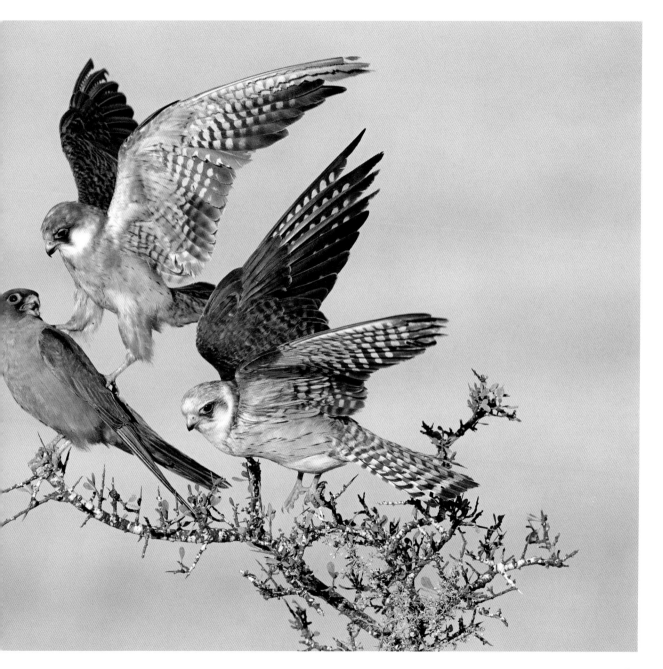

Earth's Environments

Embracing wild or man-made surroundings and the life within them, the categories in this section illustrate nature's resilience or impact on the planet.

Landscape in ash

Hans Strand

SWEDEN

Hans was flying by helicopter over southern Iceland's Fjallabak Nature Reserve in the highlands of Landmannalaugar, taking pictures for a book about Iceland's spectacular landscapes. Following a river valley, they flew under the clouds and, 'all of a sudden, this magical place appeared,' says Hans. Icefields and glaciers lined the flanks of the mountains, and they were stained with volcanic ash, recording in layers of intensity the details of the flowing movements of snow and ice. It's a region known for its volcanic activity, but with no eruptions in a few years, the fine ash could have been deposited there by wind from elsewhere. The mist meant that Hans had to shoot at a relatively low speed, but being a veteran aerial photographer, he kept the camera steady, and the low light enhanced the subtle colours of the otherworldly landscape.

Hasselblad H3DII-50 + 50mm lens; 1/500 sec at f3.4; ISO 200.

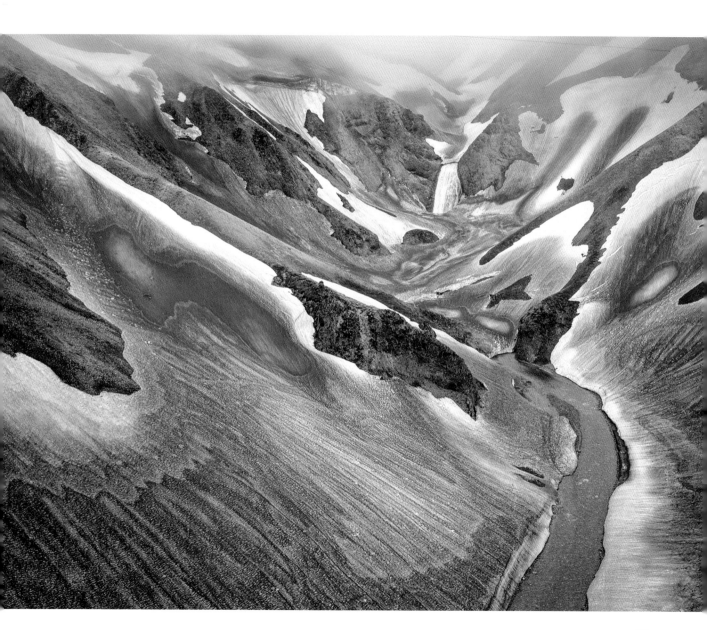

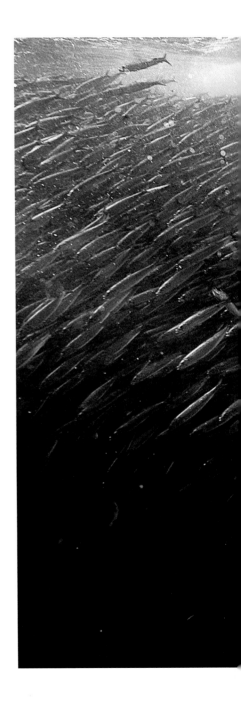

A whale of a mouthful

Michael AW

AUSTRALIA

A Bryde's whale rips through a swirling ball of sardines, gulping a huge mouthful in a single pass. As it expels hundreds of litres of seawater from its mouth, the fish are retained by plates of baleen hanging down from its palate; they are then pushed into its stomach to be digested alive. This sardine baitball was itself a huge section of a much larger shoal below that common dolphins had corralled by blowing a bubble-net around the fish and forcing them up against the surface. Other predators had joined the feeding frenzy, attacking from all sides. These included copper, dusky and bull sharks and hundreds of Cape gannets, which were diving into the baitball from above. The Bryde's whale was one of five that were lunging in turn into the centre of the baitball. Michael was diving offshore of South Africa's Transkei (Eastern Cape), specifically to photograph the spectacle of the 'sardine run' – the annual winter migration of billions of sardines along the southeastern coast of southern Africa. Photographically, the greatest difficulty was coping with the dramatic changes in light caused by the movements of the fish and the mass of attacking predators, while also staying out of the way of the large sharks and the 16-metre (53-foot), 50-ton Bryde's whales, which would lunge out of the darkness and, as he knew from experience, were capable of knocking him clean out of the water.

Nikon D3S +14–24mm f2.8 lens at 14mm; 1/250sec at f9 (-1 e/v); ISO 800; Ikelite DS-200 strobe; Seacam housing.

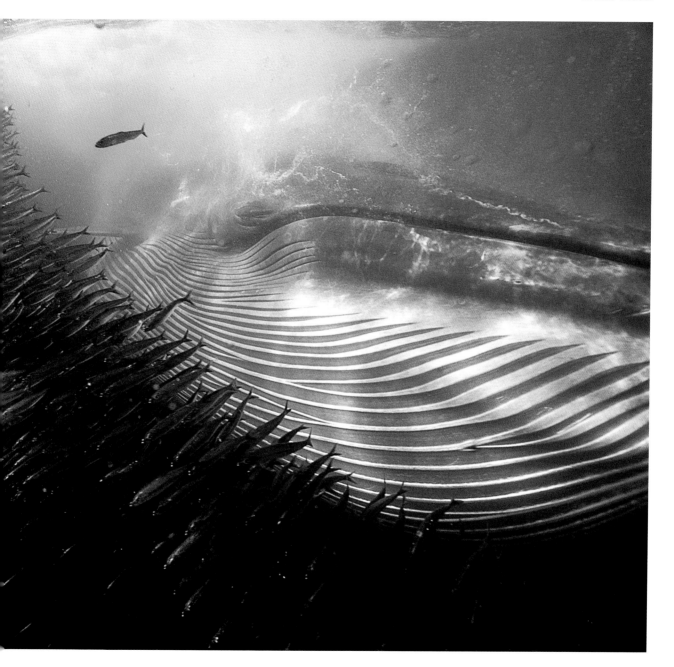

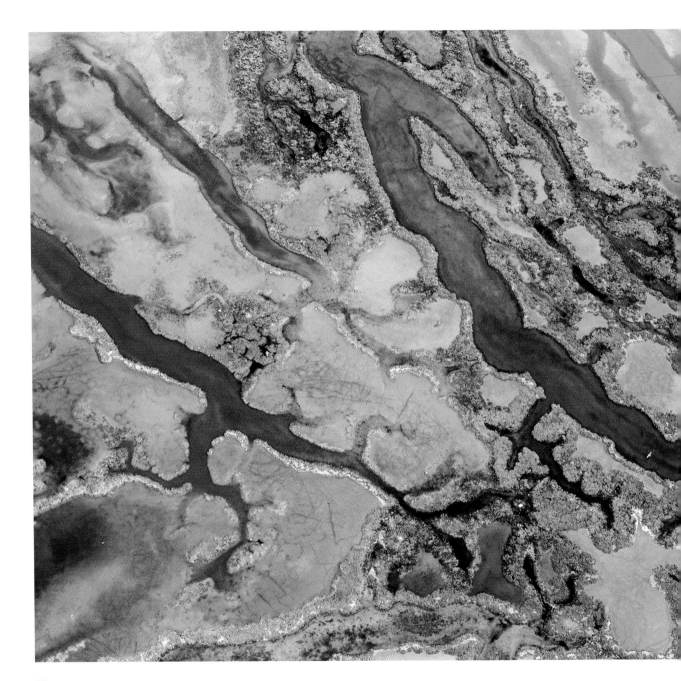

'The aerial perspective transforms stunning scenery into a gorgeous graphic. But as you look closer you spot the birds that make this a living landscape.'
Alexander Mustard

The art of algae

Pere Soler

SPAIN

The Bahía de Cádiz Natural Park on the coast of Andalucia, Spain, is a mosaic of marshes, reedbeds, sand dunes and beaches, which attracts great numbers of birds, and in spring it is an important migration stopping-off point. Pere was there for the birds but also for a spring phenomenon, only fully visible from the air. As the temperature warms and the salinity changes, the intertidal wetlands are transformed by colour as bright green seaweed intermingles with multicoloured microalgal blooms. White salt deposits and brown and orange sediments coloured by sulphurous bacteria and iron oxide add to the riot of colour. The full display usually lasts only a few weeks in May or June, but it's not possible to predict exactly when. Pere took his chances in June, hired a plane and, at midday, when the tide was out and the light was overhead, he was able to photograph the rich tapestry of colour and texture. The spectacle was, said the pilot, the most beautiful he'd seen in many years of flying over the delta.

Canon EOS 5D Mark III + 70–200mm f4 lens at 70mm; 1/1000 sec at f5.6; ISO 200.

'Even humans find the urban environment oppressive, spaces filled with rows of office buildings and houses. But many wild animals have made it a home, where predators are rare. This photograph is symbolic of the wiliness and life force of wild animals. Through it we reveal a little of their psychology and see contemporary society through their eyes.'

Kazuko Sekiji

Shadow walker

Richard Peters

UK

A snatched glimpse or a movement in the shadows is how most people see an urban fox, and few know when and where it goes on its nightly rounds. It was that sense of living in the shadows that Richard wanted to convey. He had been photographing nocturnal wildlife in his back garden in Surrey, England, for several months before he had the idea for the image, given to him by the fox when it walked through the beam of a torch he had set up, casting its profile on the side of his shed. But taking the shot proved to be surprisingly difficult. It required placing the tripod where he could capture both the cityscape night sky and the fox silhouette, a ground-level flash for a defined shadow, a long exposure for the stars, a moonless night to cut down on the ambient light and, of course, the fox to walk between the camera and the wall at the right distance to give the perfect shadow. On the evening of this shot, the neighbours switched on a light just before the vixen arrived, unaware of her presence but adding to the image.

Nikon D810 + 18–35mm lens at 32mm; 30 sec at f8; ISO 1250; Nikon SB-800 flash; Gitzo tripod + RRS BH-55 ballhead; Camtraptions PIR sensor.

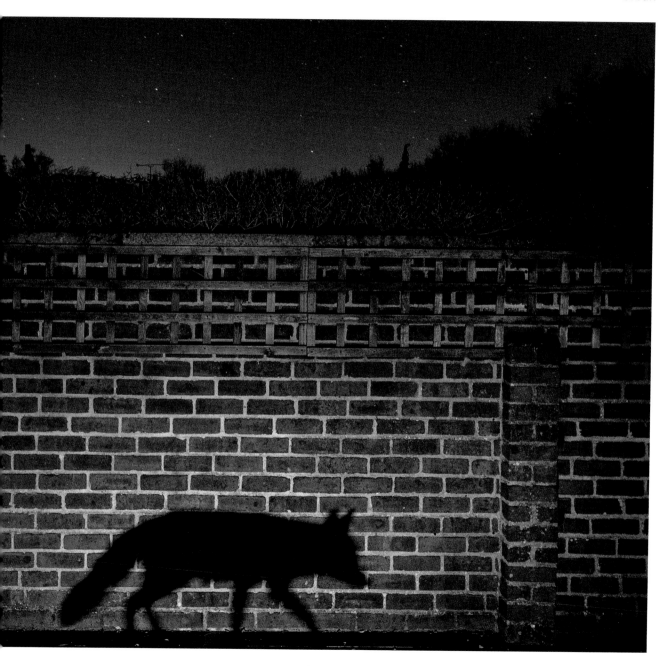

Earth's Design

Revealing Earth's rich fabric of patterns, textures, structure and forms, from an abstract or illustrative viewpoint the categories in this section expose the intricate organization and composition of the world around us.

The meltwater forest

Fran Rubia

SPAIN

There was magic in the mud. As Fran watched, invisible forces sketched a picture on the ground right in front of his boots. Meltwater from Iceland's Vatnajökull glacier, filtering through the soil on a gentle slope, set mud granules of a specific density into motion. Trunks, branches and twigs formed until an entire forest had been created in the patch of mud, and trickles of water transformed into rivers running through the woodland. Fran waited for the shadow of the huge glacier behind him to fall on the scene and give a uniform light, and then he composed his image so that the 'trees' would appear to stand up out of the mud, as in a child's pop-up picture book.

Canon EOS 6D + 24–105mm lens at 35mm; 1/8 sec at f8; ISO 400; Manfrotto 190X tripod.

'This picture is like a painting in which I can see and imagine many things, among them trees, waterfalls and canyons. Nature is an artist and the photographer, too, because they were able to capture such beauty. One of the best detail pictures I have ever seen.'

Thierry Vezon

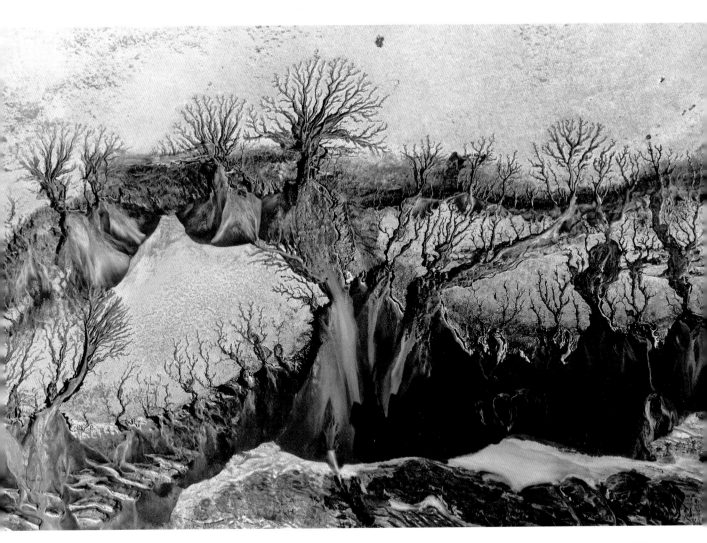

Life comes to art

Juan Tapia

SPAIN

Every year, a pair of barn swallows nests in the rafters of an old storehouse on Juan's farm in Almeria, southern Spain, entering the building through a broken windowpane. Equipment and tools are kept in the building, but the swallows seem unperturbed by people coming in and out. Last spring, Juan decided to try to take a very different image of the swallows. He first had to find the right painting to use as a prop – in the end choosing one familiar from his childhood. Making a swallow-sized hole in the oil painting, he moved it over the window that the swallows entered through. When the pair first arrived, they flew straight in through the window, unperturbed by the canvas. But rather than risk disturbing the birds that spring, he waited until the following spring to set up the shot. Using two flashes, both to light the canvas and to freeze the movement, he linked a remote control to his camera, which he positioned to shoot the entrance hole against the sky. He then retreated to his truck with his binoculars ready. He had no trip beam, and so it took 300 shots and 8 solid hours before he finally got the moment one of the swallows swooped in with the sky behind, as though it had punched straight through into another world.

Canon 7D + 70–200mm f2.8 lens at 150mm; 1/250 sec at f14; ISO 400; Canon 580EX II and Metz 58 flashes; x2 Metz photocells; Manfrotto tripod + Rótula RC2; Godox remote.

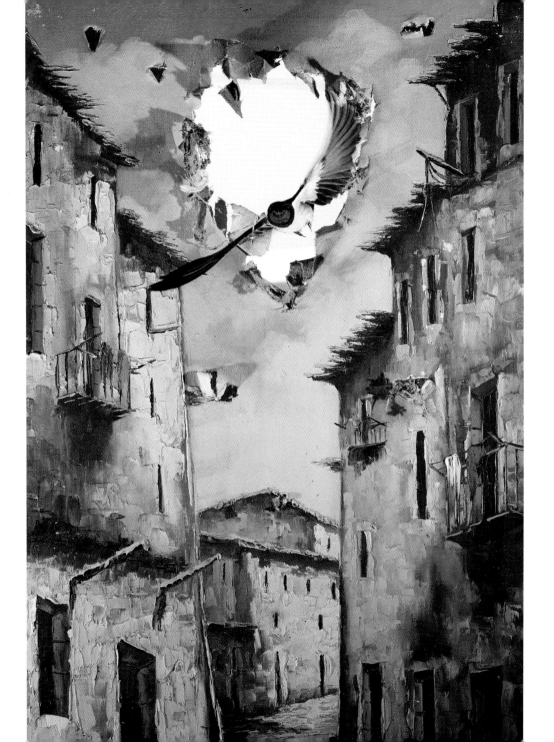

'Modern digital cameras give us the ability to capture movement because of their dramatically fast shutter speed, such that it is now possible to freeze the motion of a bird's wings. In this work, however, deliberately slowing the shutter speed has blurred the wings' motion. It is the blurring that makes this photograph impressive. This closely cropped close-up in black and white powerfully conveys the wings' speed.'

Kazuko Sekiji

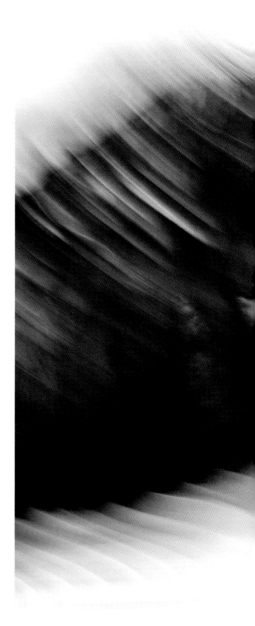

The dynamics of wings

Hermann Hirsch

GERMANY

There's that moment, just as a white-tailed sea eagle grabs a fish from the sea, when to avoid plunging into the water it must switch flight mode, speed and direction to power upwards. Hermann set out to capture the dynamic beauty of that split second, choosing black and white to simplify the image to its essentials. This involved spending 26 days on a lake in Feldberger Seenlandschaft, Germany, photographing fishing white-tailed sea eagles. The challenge was to catch the moment when the sea eagle's wings are stretched forward, while showing enough of its beak and, crucially, the eye to make it recognizable as an eagle. Panning the camera along with the movement of the bird, on a slow shutter speed to blur the motion, he focused on the head. But it took more than 50 attempts to achieve his vision.

Canon 5D Mark III + 500mm f4 lens at 500mm; 1/50 sec at f8; ISO 200.

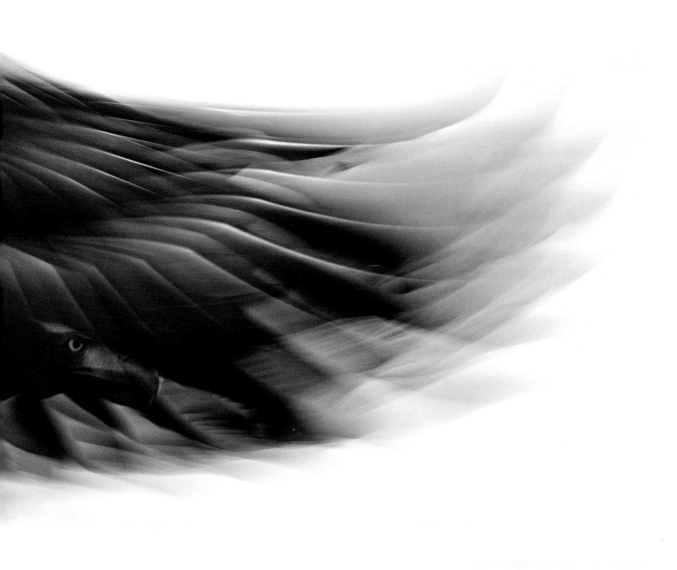

Ghosts and castles

Tobias Bernhard Raff

GERMANY

Under cover of darkness, as the tide rolls out, ghost crabs emerge
for a frantic bout of feeding. They also cover the beach with
sandcastles – excavation mounds produced as they dig out new
daytime shelters, spiral shafts into which they will retreat when
the tide rolls back in, protecting them from predators and the sun.
Tobias moored his boat in New Caledonia's Southern Lagoon and
spent a week observing and recording the ghost crabs' nocturnal
activities. He used timelapse to depict both their industriousness
and their relationship with the tides, the challenge being to light
the scene without disturbing them and to keep track of where the
crabs would pop up again when the tide went out.

GoPro 4 + f2.8 lens + 4x dioptre lens; 1 frame per 5 sec; ISO 400;
GorillaPod; Premiere Pro to output. Nikon D800 + 16–35mm f8 lens at
24mm; 1 frame per 5 sec; ISO 400; Subal housing; Manfrotto tripod;
x3 LED lights + Manfrotto monopods; Premiere Pro to output.

www.nhm.ac.uk/ghosts-and-castles

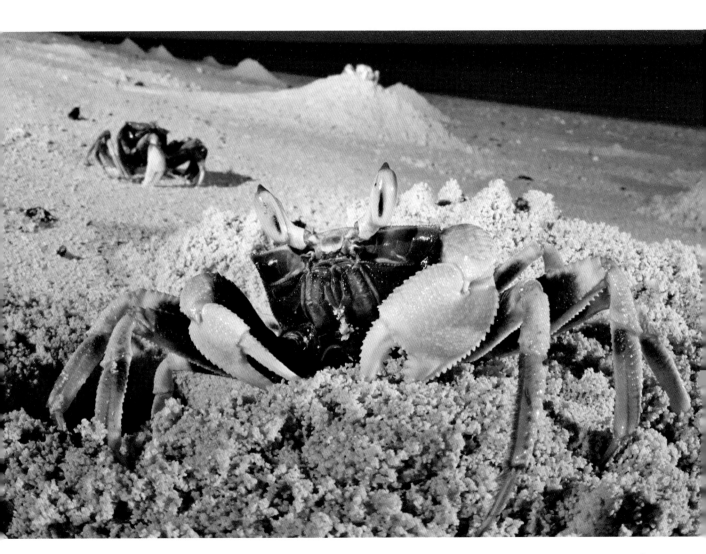

Documentary

This investigates the complex relationships between humans and the natural world through the narrative power of photography. Challenging or uplifting, provocative or revelatory, these photographs remind us how our attitudes, decisions and actions impact the natural world.

Photojournalist Single Image: Broken cats

Britta Jaschinski
GERMANY/UK

Locked into obedience by their trainers' gaze, big cats perform at the Seven Star Park in Guilin, China. They have had their teeth and claws pulled out, and when not in the arena, they live in the tiny cages visible behind the stage. At least one (centre) is a captive-bred hybrid – part lion, part tiger. In 2010, the Chinese authorities issued a directive to zoos and animal parks to stop performances that involve wild animals. But this is not legally binding, and in many facilities across the country, it is still business as usual, with shows attracting audiences unaware of the scale of the abuse, neglect and cruelty involved. For the past 20 years, Britta has travelled extensively, documenting the world of animals in captivity and their unnecessary suffering in the name of education and entertainment. But never, she says, has she come across 'such brutal and systematic deprivation' as in China. 'The potential for change is huge,' she maintains. 'Despite government control of the internet, social-media messages do get through and can make a difference. Attitudes are changing.'

Nikon F4 + 24mm lens; 1/125 sec at f5.6; Kodak Tri-X-Pan 400 black-and-white film.

'I don't blame you if you don't like looking at this photograph, especially after seeing the magnificence of wild nature in the rest of the exhibition. I had to leave the room during judging to gather my emotions. The faces of the cats speak volumes about what they have been through. The animals in this scene do not have four legs.'

Alexander Mustard

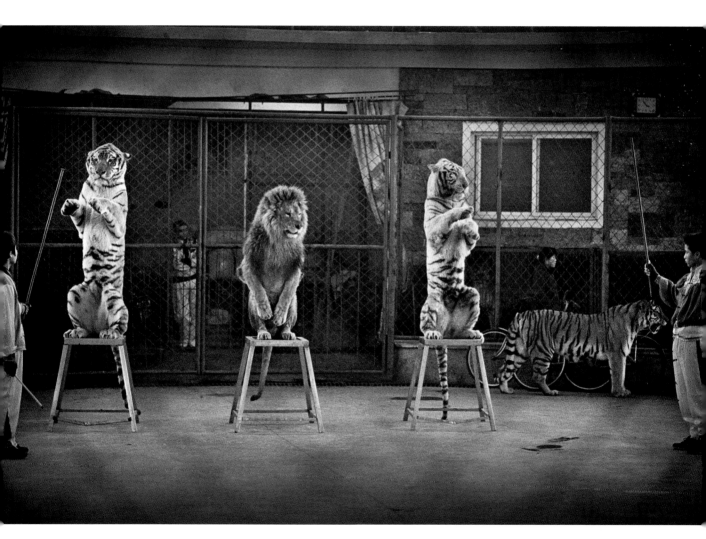

Photojournalist Story:
Ivory wars, from the frontline

Brent Stirton

SOUTH AFRICA

Elephant poaching is one of the most lucrative black markets in
the world. A kilo of raw ivory can fetch more than $2,000. Between
2010 and 2012 more than 100,000 wild savannah elephants were
poached, and two thirds of forest elephants have been killed in the
past decade. In these six images Brent set out to focus attention on
the rebel groups within Africa who are profiting most, and to draw
attention to the rangers who risk their lives to try to stop the killing.

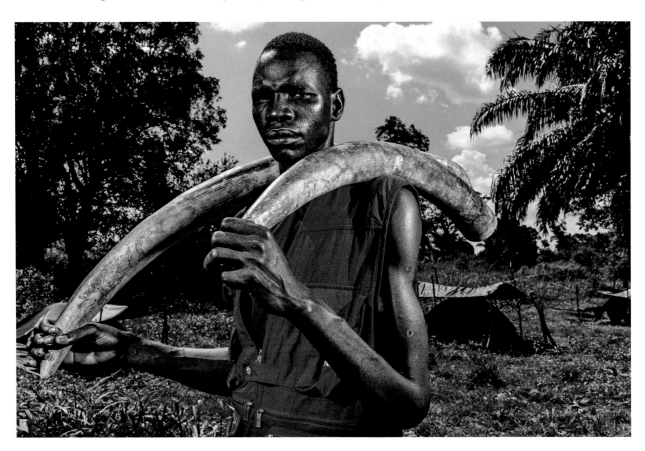

The spoils of war

Michael Oryem holds ivory tusks taken in Garamba National Park, Democratic Republic of the Congo (DRC), and buried in the Central African Republic (CAR) on its way to the notorious Lord's Resistance Army (LRA). When he was nine, Michael was abducted by the LRA, the group responsible for killing thousands of people in Uganda, South Sudan, CAR and DRC. He was commanded to kill elephants and trade the ivory with the Sudanese army for weapons; he defected 17 years later. Without access to ivory, the LRA would be weakened.

Canon EOS-1D X + 24–70mm f2.8 lens; 1/250 sec at f16; ISO 200.

The price they pay

Kambale Bemu lies dead, shot five times at point-blank range. A ranger in the DRC's Virunga National Park, he was killed by a rebel Congolese-army soldier. Kambale was one of more than 160 rangers killed in the past 10 years, many at the hands of the Rwandan rebels from the FDLR (Forces Démocratiques de Libération du Rwanda) who fled into the park after the 1994 Rwandan genocide. They have poached elephants for ivory to finance their campaigns.

Canon EOS-1D X + 24–70mm f2.8 lens; 1/80 sec at f1.8; ISO 400.

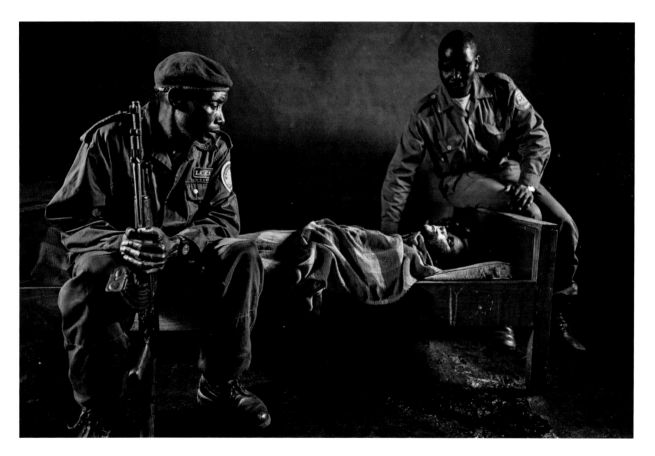

In the firing line

Rodrigue Katembo, a charismatic, passionate conservationist, leads a patrol of Congolese rangers and soldiers through a dangerous area of the DRC's Virunga National Park in search of poachers who have killed two elephants. Twenty minutes after crossing the river, they came under sustained fire from the FDLR. The park, a World Heritage Site, protects a critically important population of mountain gorillas, elephants, okapis and chimpanzees and is one of the most dangerous places in the world to practise conservation.

Canon EOS-1D X + 24–70mm f2.8 lens; 1/160 sec at f6.3; ISO 400.

Ivory widows

Bernadette Kahindo and her family are victims of the ivory trade. Her husband, Assani Sebuyori, was a dedicated ranger in the DRC's Virunga National Park, trying to stop the ivory and bushmeat trade conducted by the notorious FDLR Rwandan militia. But in 2012, the rebels ambushed Assani's park vehicle and murdered him. Bernadette has seven children to support and survives on a tiny widow's allowance, supplemented by donations from supporters of the Virunga National Park.

Canon EOS-1D X + 24–70mm f2.8 lens; 1/100 sec at f9; ISO 400.

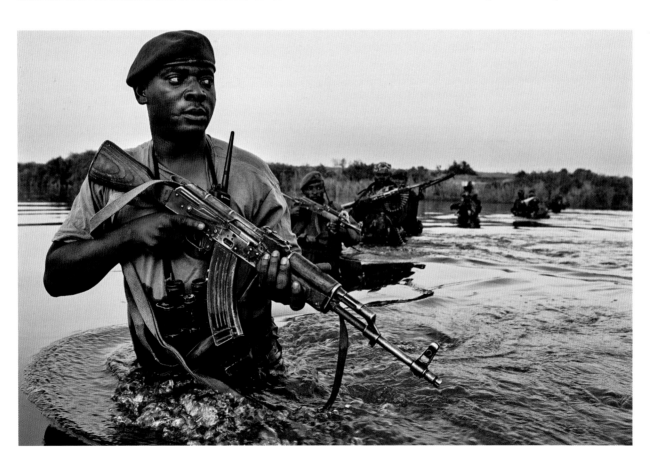

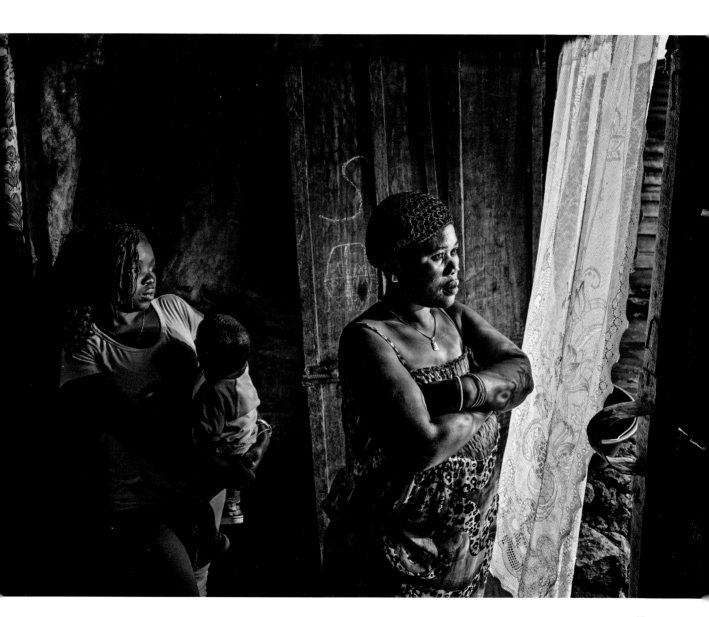

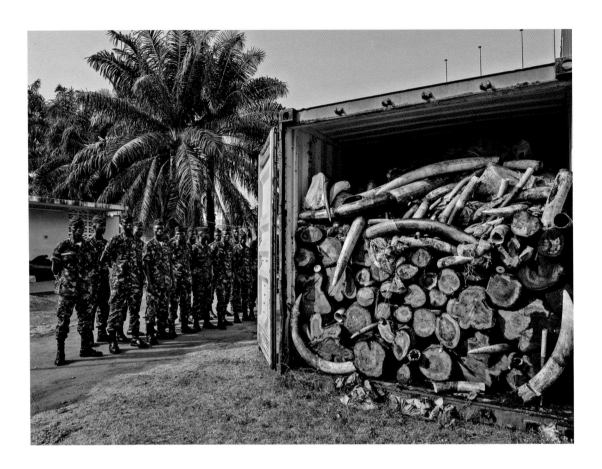

Ivory haul

Police officers in Lomé, capital and main port of Togo, guard one
of four confiscated shipping containers full of elephant tusks.
DNA evidence linked some of the ivory to a massacre in the CAR
in 2013, when anti-government Séléka rebels climbed the saltpan
observation towers, Dzanga-Ndoki National Park, and gunned
down 26 elephants. This find confirmed the link between ivory
poaching and violent political upheavals in CAR and that the port
was being used as a new route for smuggling ivory out of Africa.

Canon EOS-1D X + 24–70mm f2.8 lens; 1/125 sec at f14; ISO 200.

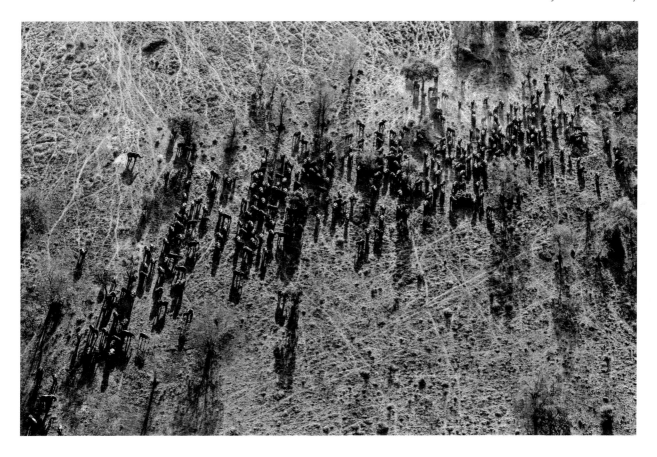

'This was an incredibly impactful portfolio. The story of poaching and ivory is a complicated, layered tale to tell, but in many ways what made this portfolio so effective is the simplicity of the photography. The images are powerful and moving, beautiful in spite of the tough subject matter. The photographer's ability to capture the nuances of the story, to tell it from every angle, and to capture the emotion and the enduring human spirit, made this a winner.'

Stella Cha

Survivors

The largest herd of elephants in Chad's Zakouma National Park moves out of the bush to a river pool. In 2002 there were about 4,300 elephants and by 2011 severe poaching meant there were about 450. Funding, a change of management, support from President Idriss Déby, and local initiatives have transformed the park. No elephant has been poached in nearly three years, and they are breeding again. Tourism has also restarted. With funding and commitment, it's possible to protect elephants from the poachers.

Canon EOS-1D X + 24–70mm f2.8 lens; 1/640 sec at f8; ISO 400.

The Rising Star Portfolio Award

This award seeks to inspire and encourage photographers between the ages of 18 and 25 and is given for a portfolio of work.

Raven strut

Connor Stefanison

CANADA

Thick, fresh snow covered the summit of Mount Hollyburn and carpeted the hemlock trees, and fog hung in the air. The conditions were perfect for landscape photography. But what Connor was there for were the ravens. The mountain, overlooking Vancouver, is a popular winter hiking area, accessible on snowshoes. The ravens know that people rest at the summit and eat food there, and so they watch for hikers and the promise of scraps. Connor's difficulty was waiting for one to alight on an area of snow free of snowshoe footprints and with the right background. Two ravens entertained him for half an hour as they prospected for food. Then finally one of them landed in the perfect spot and performed, walking across the pristine snow, displaying its characterful strutting gait.

Canon EOS 5D Mark II + 16–35mm f2.8 II lens at 16mm; 1/1000 sec at f7.1; ISO 1600.

'The softness of the scene, the monochromatic palette, the stand of trees and the gentle sweep of the hill all add up to a lovely photograph. But the addition of the crow takes things to a different level. Its stark black feathers against the snow, its seeming attitude and that strut across the hill create a hilarious contrast to the sweetness of this windswept landscape.'
Kathy Moran

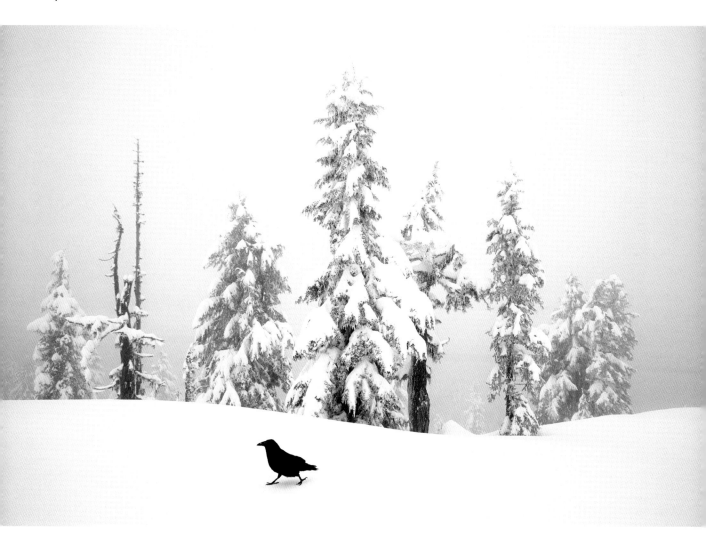

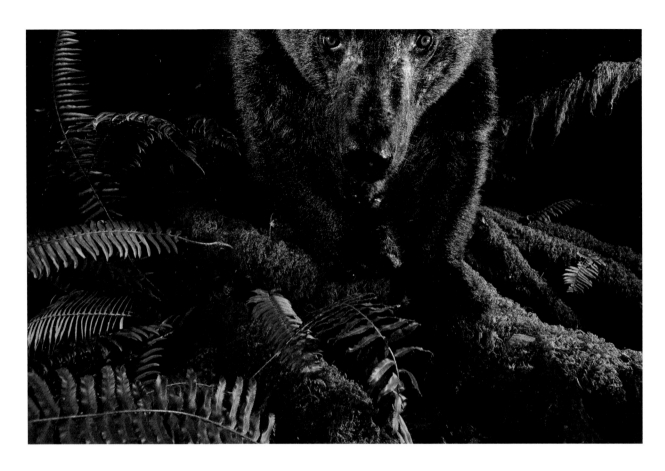

A black bear looks in

Connor set out to take a camera trap shot of a western spotted skunk in forest near Maple Ridge, British Columbia. He placed a bit of meat in front of the beam – not enough to interest a black bear. After a week, he returned and was disheartened to see a bear scat on the path. But his gear was intact. Relief turned to delight when he realized that he had an image of a black bear staring directly into the camera.

Canon Rebel XTI + Tokina 12-24mm f4 lens at 15mm; 1/200sec at f9; ISO 400; Trailmaster 1550-PS infrared trail monitor; x2 Nikon SB-28X2 and Nikon SB-800 flashes.

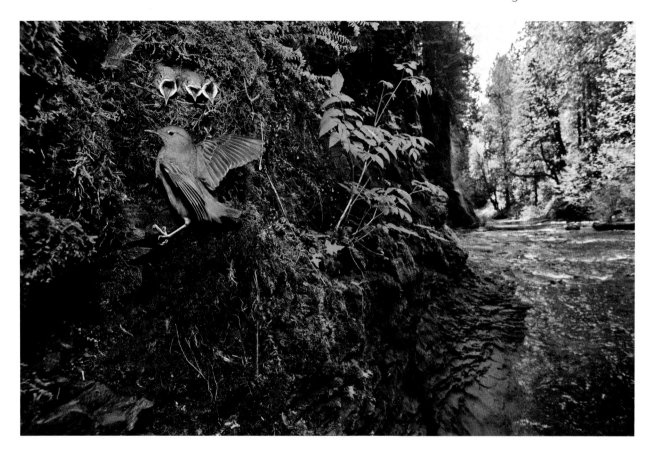

Creekside nursery

The female American dipper has delivered a beakful of invertebrates to her chicks in their riverbank nest. The most difficult aspect of the shot was setting up the equipment without disturbing the nesting birds. Connor did it gradually, one item at a time, wading across the river near Maple Ridge, British Columbia. He then got the dippers used to the camera, clicking the shutter before using any lights.

Canon EOS 5D Mark II + 16–35mm f2.8 II lens at 22mm + polarizing filter; 1/60 sec at f13; ISO 1600; Yongnuo YN-560 II and Nikon SB-800 flashes; Vello wireless remote; Gitzo tripod.

'One thing that struck the jury about this portfolio was the diversity of subject matter and photographic approaches. You have camera traps, sophisticated lighting techniques and a range of species and landscapes all rendered in a fresh, truly exciting way. This rising star is experimenting with all the tools and opportunities available as he develops his own visual voice. Case in point, the addition of just the right amount of light brings drama to what could have been a straightforward image of a mountain goat, placing it beautifully with the landscape and herd.'
Kathy Moran

Night of the mountain goats

It was a clear, starry night, which is what he had hoped for, but with barely any moonlight, framing the mountain goats had to be a matter of guesswork. The dominant billy goat had just lain down for a short rest a few metres away, and so this was the moment for an image. It was late September, and the goats were already growing their thick winter coats. They had descended from their daytime grazing area in the heights of British Columbia's Selkirk Mountains to feed on the flatter ground. This was where Connor had camped for three days, to allow the goats to get used to his presence. In fact, they were so accustomed to him that one brushed past as he was photographing another. Now, framing a shot was the problem. Connor used a long exposure for the stars and a gentle manual flash, first to light the billy goat, then again for the rest of the herd grazing behind, keeping his fingers crossed that the goat wouldn't move for the 25 seconds he needed.

Canon EOS 5D Mark II + 16–35mm f2.8 lens at 16mm + Vello cable release; 25 sec at f4; ISO 3200; Canon 430EX II flash; Gitzo GT3542LS tripod.

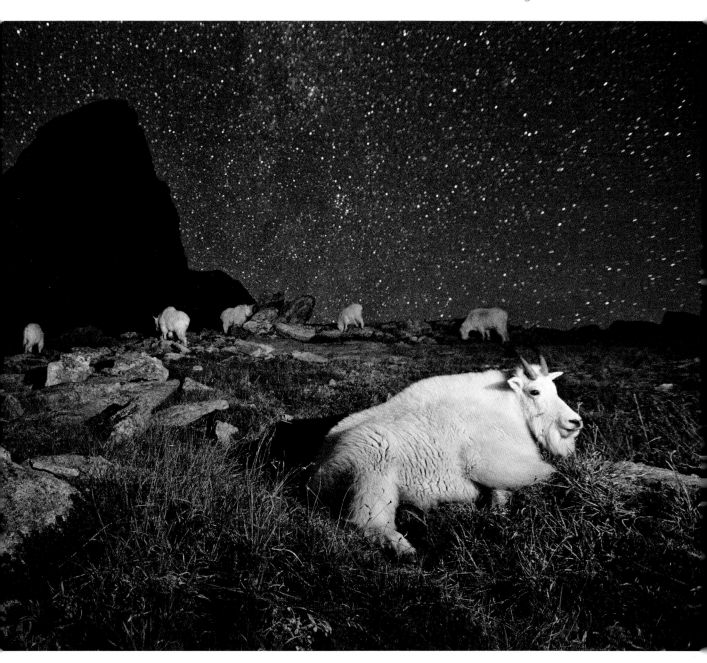

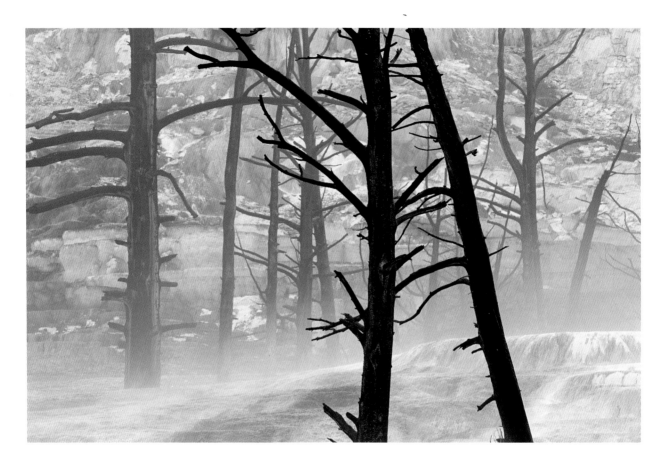

Hot spring skeletons

Eerie skeletons emerge from the sulphurous steam of geothermal pools at Mammoth Hot Springs in Yellowstone National Park, Wyoming, USA. The dead trees have been glued into place by calcium carbonate mineral deposits, which also create constantly changing terraces of travertine. Heat-loving micro-organisms tint these into a tapestry of colour.

Canon EOS 5D Mark II + 70–200mm f2.8 IS lens at 200mm + B+W polarizing filter + Vello cable release; 10 sec at f16; ISO 200; Gitzo tripod.

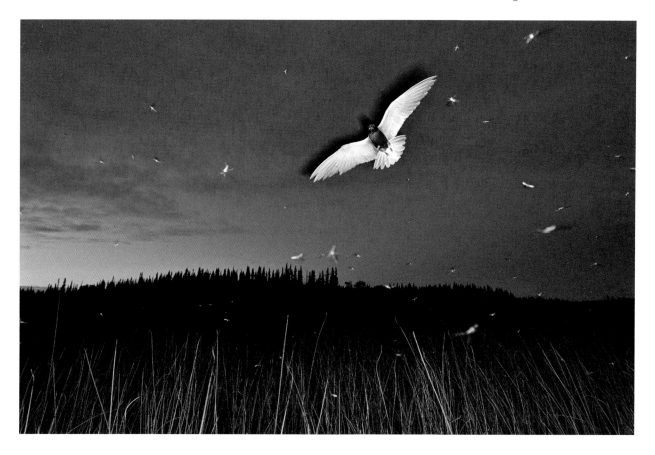

Aerial buffet

Standing in a freshwater marsh near Williams Lake, British
Columbia, Connor was photographing black terns as they foraged
after sunset. Using a wide-angle lens and a flash to light the
mosquitoes as well as the birds, his aim was to reveal that black
terns carry on feeding after dark. He soon realized that some were
swooping closer, not just for territorial reasons but also taking
advantage of the thick cloud of mosquitoes clustered around him.

**Canon EOS-1D Mark IV + 16–35mm f2.8 lens at 16mm; 1/60 sec at f8;
ISO 2500; Canon 580EX II flash.**

Young Wildlife Photographers

The Young Wildlife Photographer of the Year 2015 is Ondřej Pelánek, the winner of the 11–14 category. The other categories are 10 and under, and 15–17.

Ruffs on display

Ondřej Pelánek
CZECH REPUBLIC

Snoring was all Ondřej could hear – from his father, who had fallen asleep in the hide. The ruffs displaying in front of him were silent. The hide that Ondřej and his father had erected was on the Norwegian Varanger Peninsula, beside a traditional ruff lek – an open grassy area where males stake out small display arenas into which they attract females and which they defend against other males. It was midnight, but being the Arctic summer, the sun was above the horizon and there was enough light to photograph by. And as the ruffs were displaying all through the night, Ondřej and his father were taking it in turns to rest, except that Ondřej was so excited that he couldn't sleep. Ten males were puffing up their ruffs and head tufts and strutting around their small territories, keeping rivals at bay. As females were present, the display activity had increased. Ondřej's winning shot captures the moment when one male has lunged forward and leapt up to assert his territorial rights over another nearby male.

Nikon D800 + 300mm f2.8 VR II lens + TC-20E III; 1/500 sec at f7.1 (-1 e/v); ISO 4000.

Ondřej Pelánek

Ondřej was given a small compact camera when he was eight and quickly became a keen nature photographer, shooting insects and other animals near his home in the Czech Republic. Wanting to know the names of the creatures he had photographed, Ondřej started using field guides. Now, at 14, he is a knowledgeable naturalist – winner of his region's 'biological olympic games' three years in a row. He is also an accomplished bird artist.

'This is a complex, beautifully layered photograph, a surprisingly sophisticated way of seeing that generated a buzz on the jury. There are lots of good photographs of ruffs on the lek, getting ready to display, but very few capture the behaviour with such intensity and grace.'

Kathy Moran

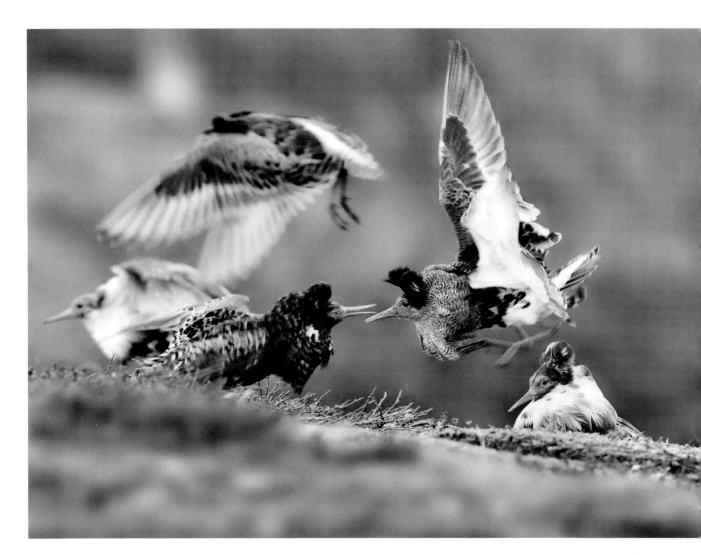

'Anyone who photographs birds wants to capture the moment they spread their wings. Capturing, in focus, a bird in flight in this narrow frame is an extraordinarily difficult feat, no matter what equipment you use. In this photograph, stillness and motion mingle. The high quality of this work makes us look forward to this promising photographer's future contributions.'

Kazuko Sekiji

Summer days

Carlos Perez Naval

SPAIN

European bee-eaters are among Carlos's favourite birds. There is a colony near his grandmother's village of Castrojeriz in Burgos, northern Spain, and every summer he visits it. The nests are in a sandy bank near a small river and beside a path, where he sets up his home-made hide and settles down to watch. The bee-eaters catch dragonflies from the river as well as bees, wasps and butterflies. When they bring food to their mates or feed their chicks, they often perch on this one branch before entering their nest holes. To take his winning shot, Carlos arrived first thing in the morning, before the light was too intense and while it was not too hot. He wanted to frame one perching and one flying in the same shot, which meant waiting and being ready for the moment. Carlos loves the breeding colours and songs of bee-eaters, and they remind him of long summer holidays with his grandmother.

Nikon D7100 + 200–400mm f4 lens + 1.4x extender at 550mm; 1/1250 sec at f5.6; ISO 500; tripod; hide.

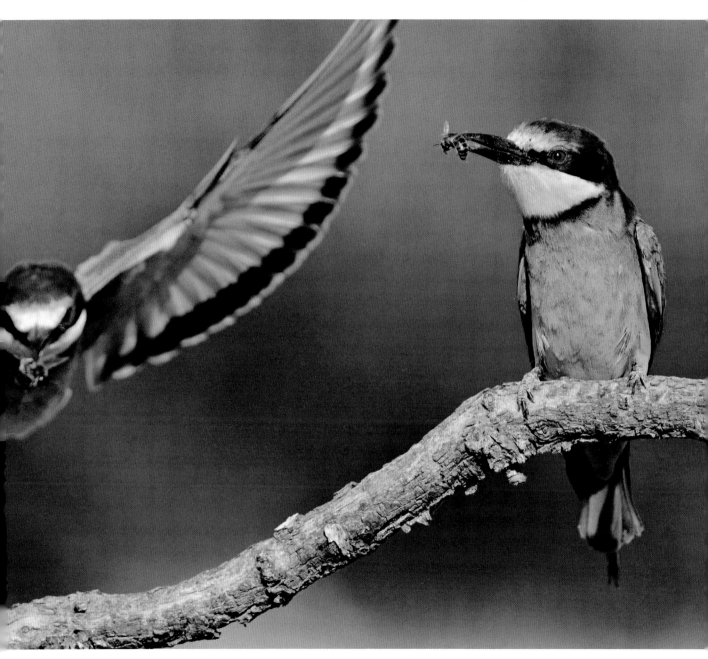

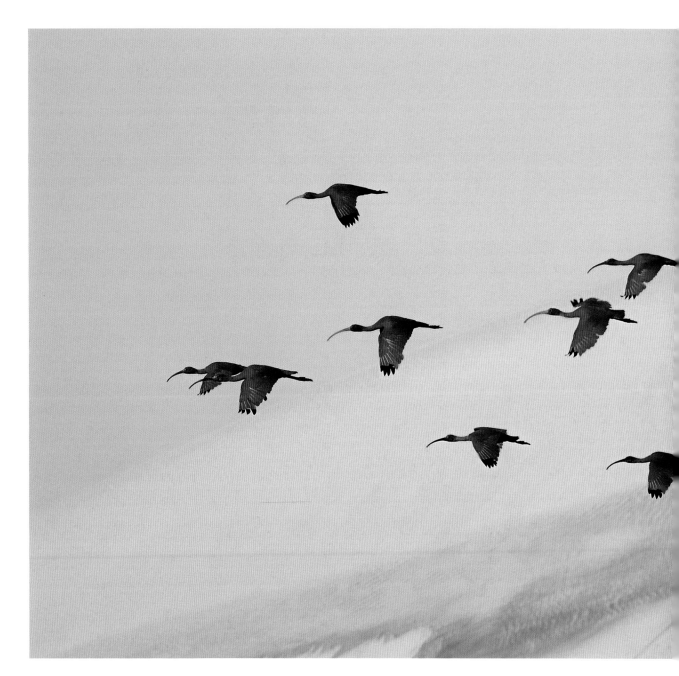

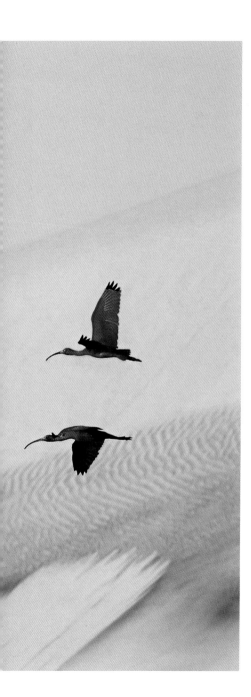

'This picture has great impact: only three colours, good graphic quality and huge energy. Congratulations to this young photographer.'
Thierry Vezon

Flight of the scarlet ibis

Jonathan Jagot

FRANCE

Jonathan has been sailing round the world with his family for five years, and for the past three years he has been taking wildlife photographs. It was when they anchored off the island of Lençóis on the coast of northeast Brazil that he saw his first scarlet ibis – the most beautiful birds he had ever seen. He discovered that at high tide they roosted in the mangroves and that at low tide they flew to the mudflats to feed on the crustaceans and shellfish with their probing curved beaks. He learned their favourite feeding spots and when to expect them. But they were very nervous, and so he had to be careful not to get too close, and the pictures of them on the mudflats or in the mangroves were never quite right. Then he had an idea: he would photograph a flock framed against the beautiful dunes that the island is famous for. At low tide, he took his dinghy into an estuary at one end of the island, anchored where he had a view of the dunes and waited. As the tide rose, so did the ibis, creating a glorious pattern of scarlet wings against the canvas of sand and tropical blue sky.

Nikon D5100 + 55–300mm f4.5–5.6 lens at 300mm; 1/1000 sec at f6.3; ISO 360.

People's Choice

As well as the winning images showcased in the 2015 Wildlife Photographer of the Year Exhibition, the jury has selected a further 25 images for a global public vote, in recognition of both the high standard of entries and following its success in 2014.

Proof that geckoes can stick to anything

Raoul Slater

AUSTRALIA

Geckoes catch insects nightly, attracted by an illuminated billboard outside a surf shop in Ubud, Bali. Raoul made four visits to the billboard before one geckoe adhered just where he wanted, on that raunchy haunch.

Canon PowerShot A4000 IS; 1/125 sec at f5; ISO 400.

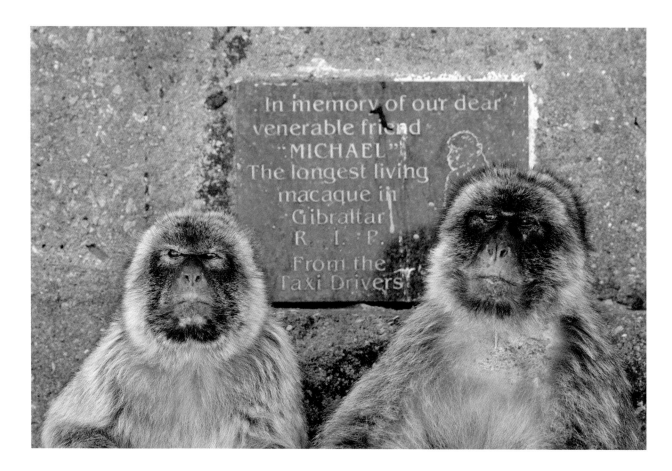

Macaque memories

Edwin Giesbers

THE NETHERLANDS

The Barbary macaque, *Macaca sylvanus*, is the only monkey species living in the wild in Europe, with populations in the Atlas Mountains of Algeria and Morocco, and here on the Rock of Gibraltar.

Nikon D7100 + 80–400mm lens; 1/250 sec at f/5; ISO 200.

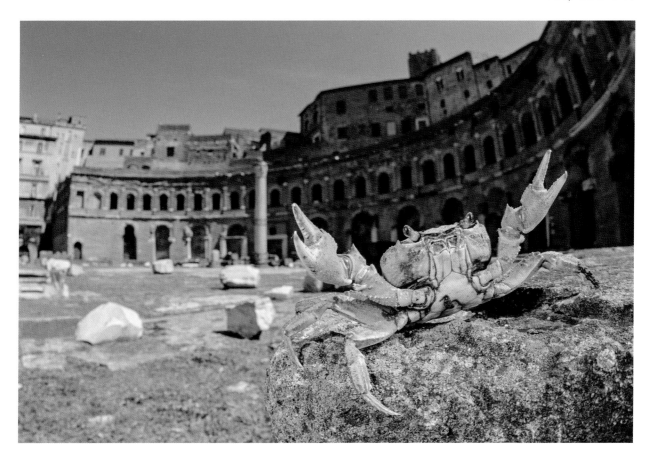

The gladiator crab

Emanuele Biggi

ITALY

This freshwater crab, *Potamon fluviatile*, is part of an old and giant-sized population that lives near small channels connecting a complex of ruins, called Trajan's Market, to the ancient sewage system 'Cloaca Maxima' in the centre of Rome, Italy.

Nikon D800+ Sigma 15mm fisheye lens; 1/100 sec at f13; ISO 100; fill-flash.

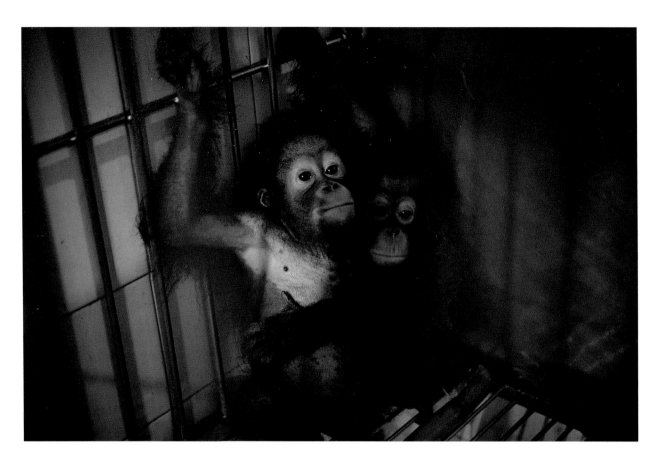

Orang-utan orphans

Yosuke Kashiwakura

JAPAN

These orang-utan orphans were huddled together against the back wall in the Sepilok Orangutan Rehabilitation Centre, in Sabah, Borneo, one with a vigilant eye towards the camera and the other looking down with frightened eyes.

Sony ILCE-7R + 55mm f1.8 lens at 55mm; 1/50 sec at f1.8 (-1 e/v); ISO 1600.

Kinship

Christian Ziegler

GERMANY

A bonobo, humankind's closest living relative, in the deep rainforest of the Congo basin. Endemic to the forests south of the Congo river, this ape is very rare and elusive.

Canon EOS-1D Mark IV + 300mm f2.8 lens; 1/250 sec at f2.8; ISO 2000.

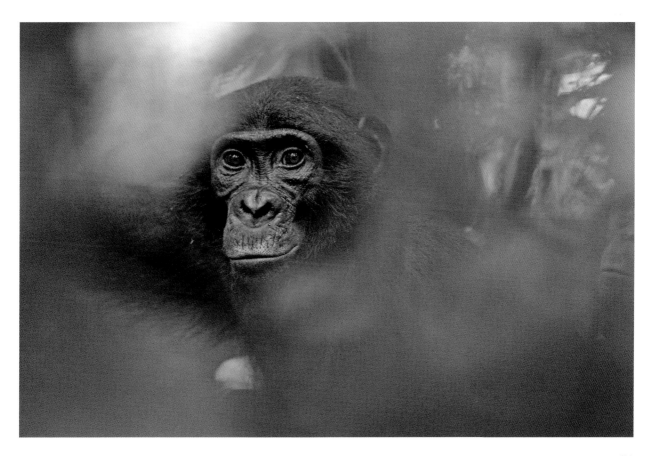

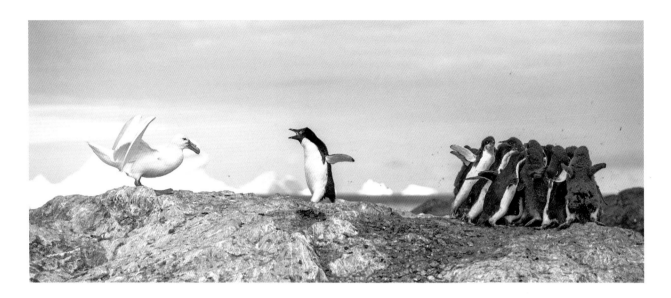

A mother's courage

Linc Gasking
AUSTRALIA/NEW ZEALAND

Just when all seemed lost, the Adélie penguin mother strode out courageously and faced off the rare all-white southern giant petrel that was cornering the cowering crèche of screaming chicks.

Nikon D3X + 70–200mm lens.

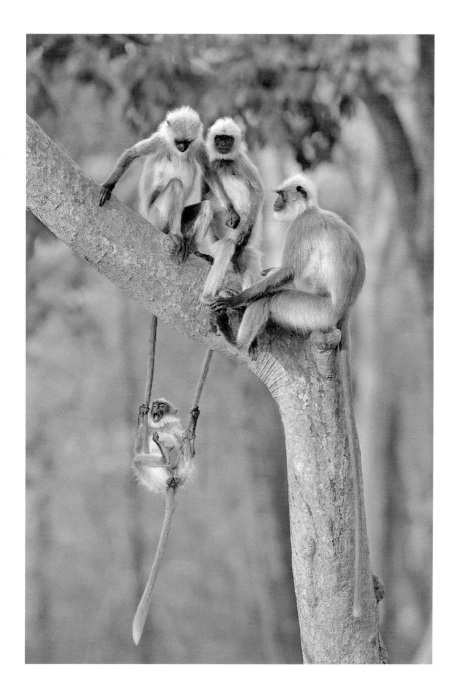

A swinging time

Thomas Vijayan

INDIA

Whilst on safari in India, these grey langurs caught Thomas's attention. As the evening light fell, he watched mesmerized as a small langur came down from a branch and used the tails of two others to swing.

Nikon D4 + 300mm lens; 1/1250 sec at f5.6; ISO 1000.

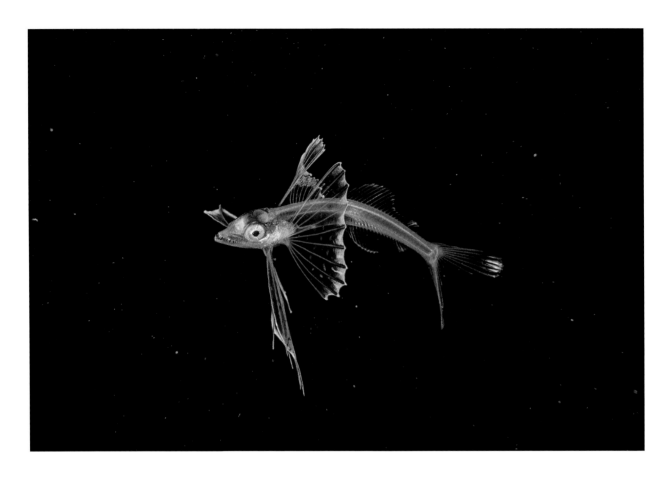

Spinning tripod

Anthony Berberian

FRANCE

Diving late at night, far offshore Tahiti Island, French Polynesia,
Anthony caught this very rare and deep-water juvenile tripod
fish deploying its fins and spinning around whilst diving deeper
and deeper.

Nikon D800E + 60mm f2.8 macro lens; 1/250 sec at f18; ISO 200;
Nauticam housing; Inon strobes.

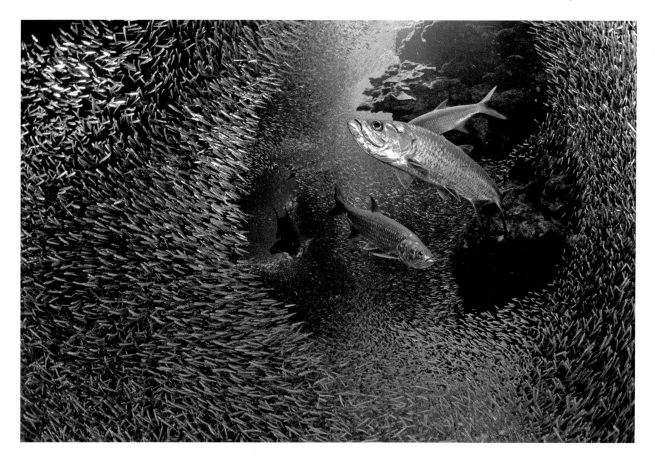

Swinging through the silverside school

Mirko Zanni

SWITZERLAND

Mirko shot this tarpon swimming through a school of silversides, which, for a short time every year, swarm caves at Devil's Grotto off the Caribbean island of Grand Cayman.

Canon EOS 5D Mark II + 15mm f2.8 fisheye lens; 1/60sec at f6.3; ISO 200; two Sea & Sea 250 strobes.

Autumn in Louisiana swamp

Georg Popp

AUSTRIA

An autumn scene in a bald cypress forest, Louisiana, USA. Because there is no firm ground in the swamps, Georg had to balance his tripod on submerged tree roots.

Toyo Field 45 AII + 210mm f5.6 lens + ND 0.6 graduated filter; 1 sec at f22; ISO 40.

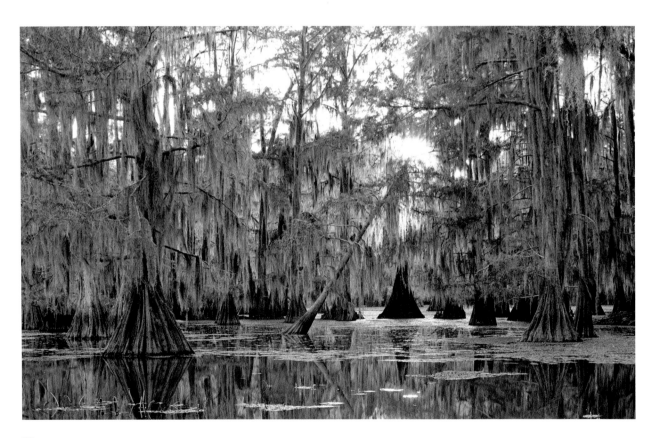

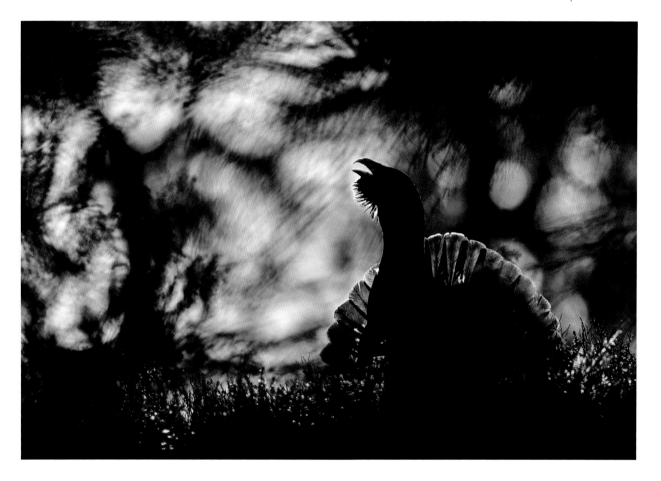

Strutting capercaillie

Bernt Østhus

NORWAY

A capercaillie strutting with its tail spread to attract a female mate. This image was the result of several days work with the birds displaying in front of the rising sun.

Canon EOS 5D Mark III + 600mm f4 lens + 1.4x extender; 1/1000 sec at f5.6; ISO 1250; tripod.

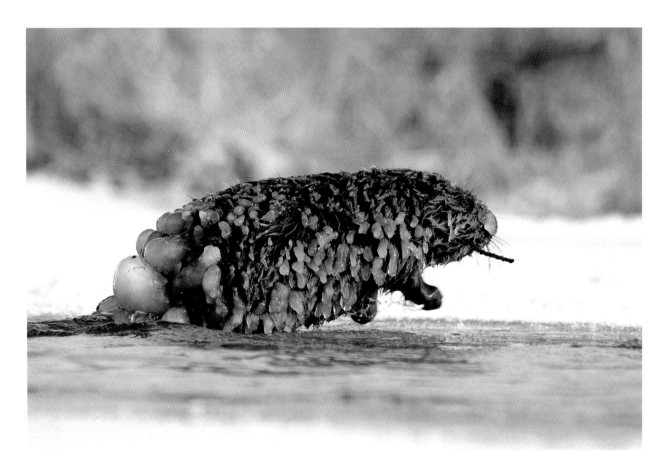

The ice ball

Łukasz Łukasik

POLAND

Łukasz was walking along the Biebrza river in northeastern Poland when he saw this ice-laden beaver trying to get out of the water. When he returned the following day, there was blood on the ice surrounded by tracks of wolves.

Canon EOS 40D + 100–400mm f4.5–5.6 lens at 390mm; 1/500 sec at f7.1; ISO 320.

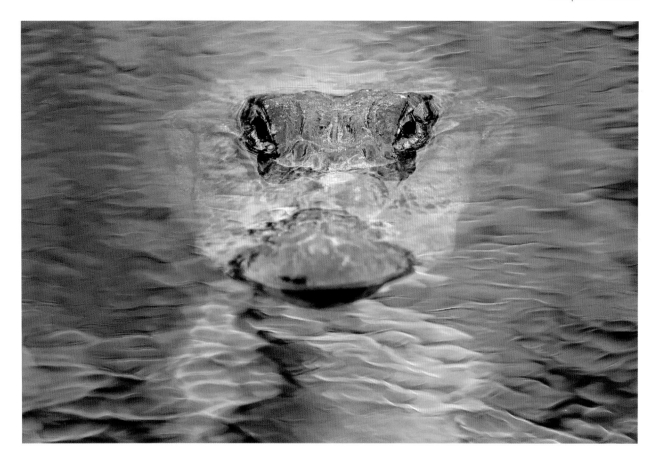

The eyes have it

Mac Stone

USA

A setting sun painted a stand of live oaks a fiery orange, dappling the water of Alachua Sink, Paynes Prairie Preserve State Park, Florida. Alligators congregate here to take advantage of the large concentrations of fish.

Canon EOS 30D + 100–400mm f4.5-5.6 lens; 1/50 sec at f/5.6; Manfrotto tripod..

Warrior of the grassland
Anup Deodhar

INDIA

Anup wanted to portray the aggressive nature of this male fan-throated lizard from the Maharashtra state, India. They engage in fierce territorial fights during the breeding season.

Nikon D7100 + 300mm f4 lens; 1/1600 sec at f5.6; ISO 250.

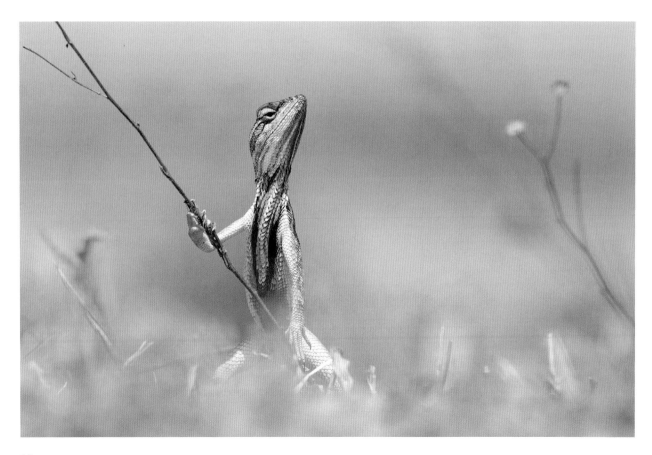

Walrus in the midnight sun

Audun Rikardsen

NORWAY

In May 2014 a walrus arrived on a beach outside Tromsø, northern Norway and, after two weeks approached Audun and gently touched his hand with its whiskers. A new friendship began.

Canon EOS 5D Mark III + 8–15mm f4 lens; 1/250 sec at f11; ISO 2500; Aquatech housing.

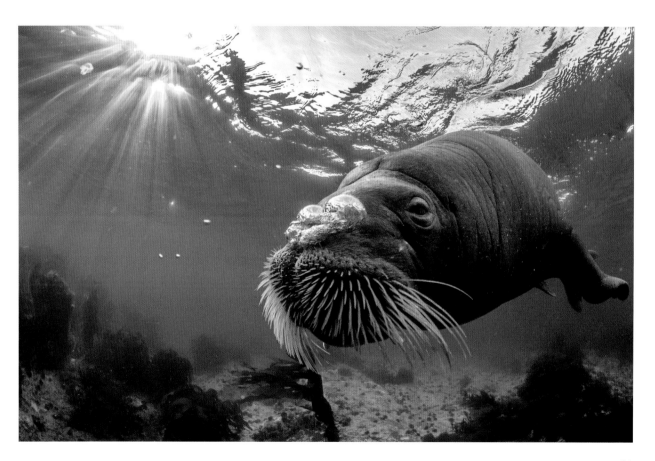

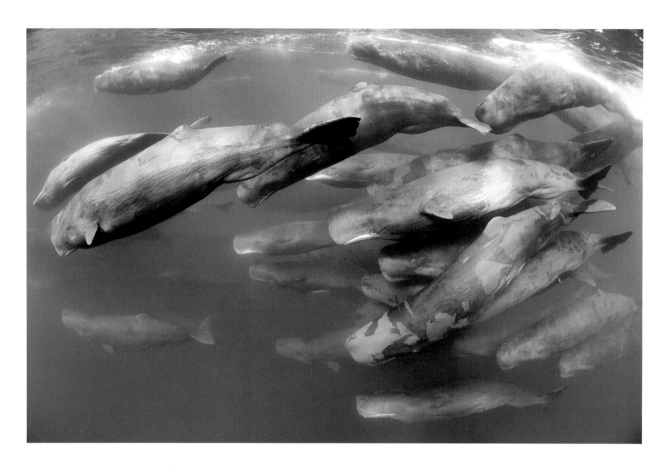

Sociable sperm whales

Tony Wu

USA

This is part of an enormous aggregation of mostly female sperm whales in Sri Lanka, which fed intermittently but also spent a substantial time socializing in shallow water at the surface.

Canon EOS 5D Mark III; 15mm f2.8 fisheye lens; 1/250 sec at f7.1; ISO 800.

Jump! Quickly!

Andrew Lee

USA

Three small smelts were scooped up into the humongous bill of the pelican. The rising sun lit the smelts and they seemed to encourage each other to escape – only one made it.

Nikon D610 + 70–200mm f4 lens at 185mm; 1/800 sec at f5.6 (-1.3 e/v); ISO 360.

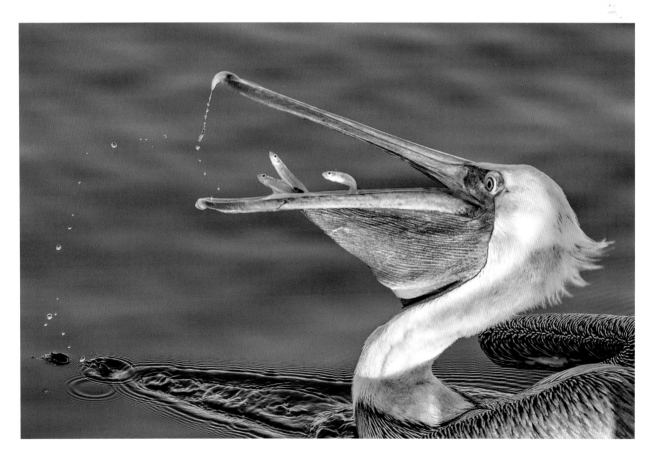

Strings of beads

Pekka Tuuri

FINLAND

A male and a female common toad spawning in Seutula, Vantaa, Finland. They are encircled by a web of strings containing double rows of eggs.

Canon EOS 5D Mark III + 15 mm lens; 1/60 sec at f11; ISO 800; Inon Z240 flash.

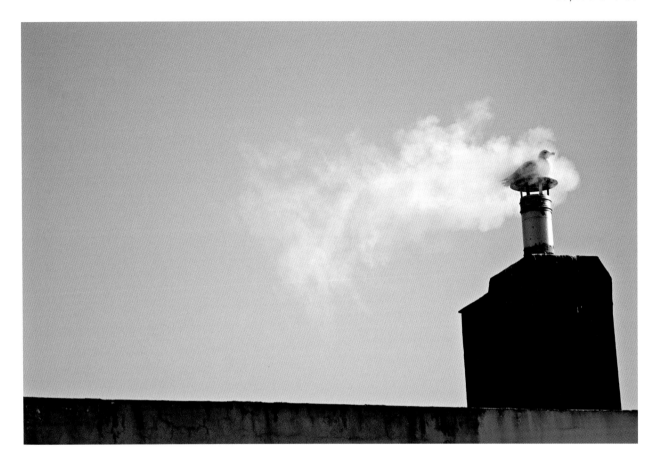

Warming up

Marco Maggesi

ITALY

This yellow-legged gull has chosen to warm itself on a chimney
pot during a bright winter's day in Genoa, Italy.

Nikon D7000 + 300mm f4 lens; 1/5000 sec at f4; ISO 200.

Nightfall at the edge of the colony

Claudio Contreras Koob

MEXICO

At nightfall the Caribbean flamingo colony at the Ria Lagartos Biosphere Reserve, Yucatán Peninsula, Mexico, starts to choose its roosting sites, with the afterglow of the sunset producing a strong fuchsia-colour.

Canon EOS 5D Mark II + 300mm f2.8 lens + 2x extender; 0.8 sec at f25; ISO 1600.

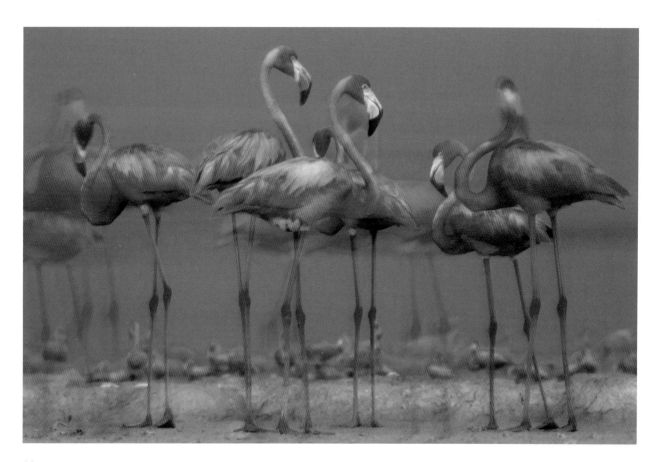

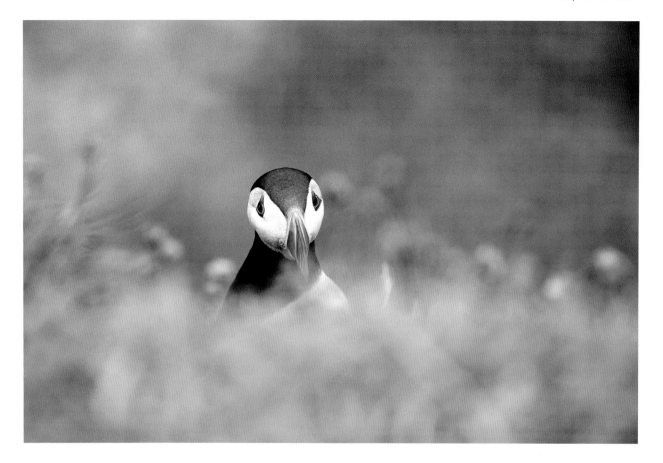

Amongst flowers

Laura Albiac

SPAIN

Laura had seen her brother lying on the ground to take photos, so she decided to do the same. The result was this shot of a puffin amongst flowers on an island near Kilmore Quay, County Wexford, Ireland.

Canon EOS 30D + 70–200 f4 lens; 1/1250 sec at f4; ISO 320.

Black and white

Darío Podestá

ARGENTINA

Because of the ice and snow, and the subjects being mainly black and white, to create this shot of gentoo penguins Darío decided to prioritize the dark areas and overexpose the white ones.

Canon EOS 7D + 70–200mm f2.8 lens; 1/250 sec at f14 (+1.7 e/v); ISO 320.

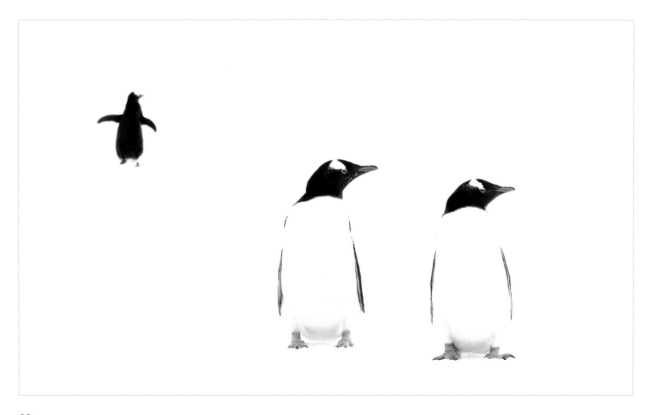

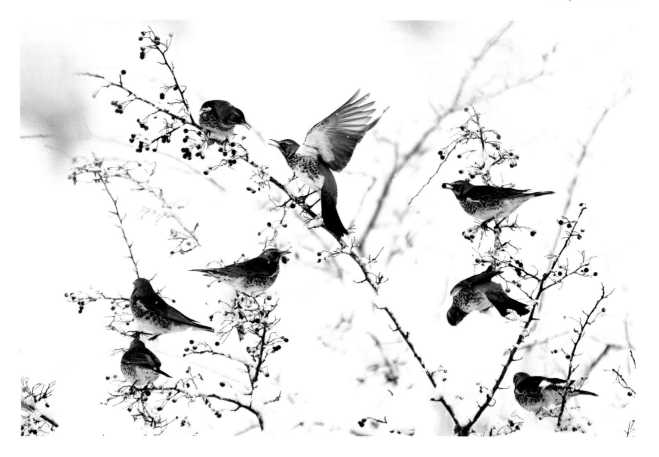

Berries for the fieldfares

Joël Brunet

FRANCE

A flock of fieldfares gathered in a tree in Bugey, eastern France. The berries provided the only source of food during this particularly harsh winter.

Canon EOS 70D + Sigma 120–300mm f2.8 lens; 1/1600 sec at f4.0; ISO 400.

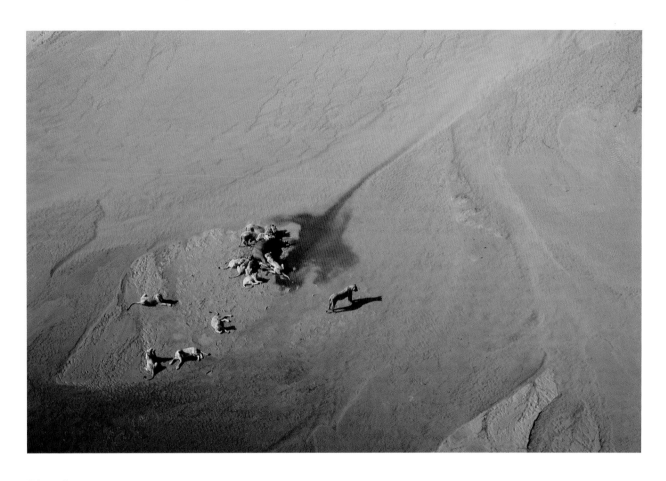

Blood river

Antoine Marchal

BELGIUM

This photograph was shot from a spotting plane. The pride of 12 lions is feeding on a buffalo killed in the riverbed of the White Umfolozi River, KwaZulu-Natal, South Africa.

Nikon D80 + 70–300mm f4.5–5.6 lens; 1/800 sec at f5.6; ISO 200.

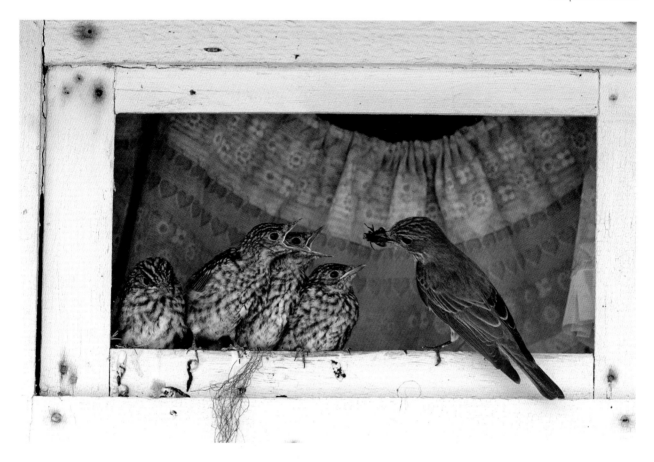

Feeding time

Peter Lilja

SWEDEN

A spotted flycatcher is feeding its young at their nest, framed by an old broken window, in an outhouse in Batvik, Västerbotten, Sweden.

Nikon D300 + 200–400mm f4 lens at 270 mm; 1/400 at f5; tripod.

Index of Photographers

87
Laura Albiac
SPAIN
lauraalbiac@gmail.com

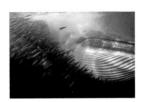

30–31
Michael AW
AUSTRALIA
one@michaelaw.com
www.MichaelAW.com

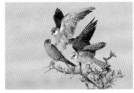

26–27
Amir Ben-Dov
ISRAEL
amir.bendov@gmail.com
www.amirbendov.zenfolio.com

74
Anthony Berberian
FRANCE
arava12@yahoo.fr

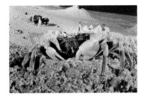

42–43
Tobias Bernhard Raff
GERMANY
wildimages@hotmail.com
www.tobiasbernhard.com
Agents
www.gettyimages.co.uk
www.corbisimages.com
www.biosphoto.fr
www.photoshot.com

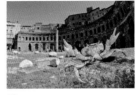

69
Emanuele Biggi
ITALY
ebiggi@anura.it

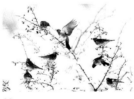

89
Joël Brunet
FRANCE
ecorces155@yahoo.fr
www.ecorcesdimages.com

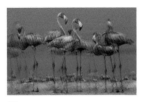

86
Claudio Contreras Koob
MEXICO
cckoob@yahoo.com

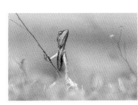

80
Anup Deodhar
INDIA
anupdeodhar@gmail.com

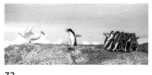

72
Linc Gasking
AUSTRALIA/NEW ZEALAND
lincgasking@gmail.com

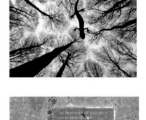

24–25, 68
Edwin Giesbers
THE NETHERLANDS
info@edwingiesbers.com
www.edwingiesbers.com
Agent
www.naturepl.com

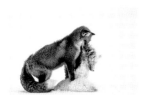

6-7, 20–21
Don Gutoski
CANADA
dgutoski@sympatico.ca
www.pbase.com/wilddon

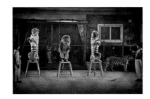

44–45
Britta Jaschinski
GERMANY/UK
info@brittaphotography.com
www.brittaphotography.com

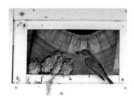

91
Peter Lilja
SWEDEN
peter@peterlilja.com

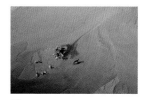

90
Antoine Marchal
BELGIUM
marchal.ant@gmail.com

40–41
Hermann Hirsch
GERMANY
Hermann.Hirsch@gmx.de
www.hermann-hirsch.de

70
Yosuke Kashiwakura
JAPAN
kashiwakura7@gmail.com

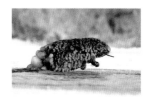

78
Łukasz Łukasik
POLAND
lukasz-lukasik@tlen.pl

22–23
Ugo Mellone
ITALY
u.mellone@gmail.com
www.wildphoto.it

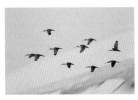

64–65
Jonathan Jagot
FRANCE
worldtravelerjohn@hotmail.fr

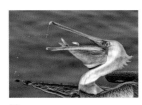

83
Andrew Lee
USA
Dr.AJLee@gmail.com

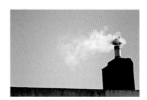

85
Marco Maggesi
ITALY
ch4oss@hotmail.com

77
Bernt Østhus
NORWAY
Bernt.osthus@staurholding.no

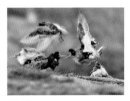

60-61
Ondřej Pelánek
CZECH REPUBLIC
ondrap2@gmail.com
www.phototrip.cz

62-63
Carlos Perez Naval
SPAIN
enavalsu@gmail.com
www.carlospereznaval.wordpress.com

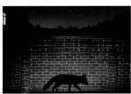

34-35
Richard Peters
UK
richard@richardpeters.co.uk
www.richardpeters.co.uk

88
Darío Podestá
ARGENTINA
dhpodesta@yahoo.com.ar

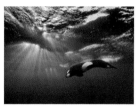

18–19, 76
Georg Popp
AUSTRIA
georg.popp@popphackner.com
www.popphackner.com
office@popphackner.com

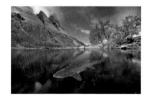

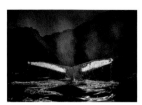

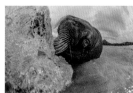

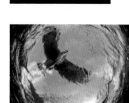

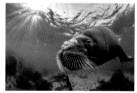

8-17, 81
Audun Rikardsen
NORWAY
audun.rikardsen@uit.no
www.audunrikardsen.com

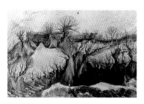

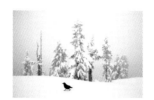

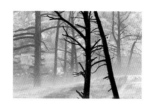

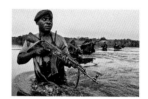

36–37
Fran Rubia
SPAIN
frankfhenix23@hotmail.com
www.franrubia.com

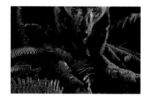

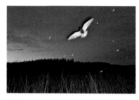

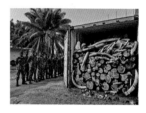

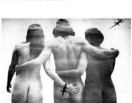

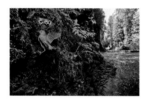

52–59
Connor Stefanison
CANADA
connor_stef@hotmail.com
www.connorstefanison.com

66–67
Raoul Slater
AUSTRALIA
wilddog@spiderweb.com.au

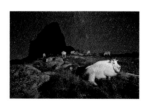

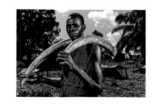

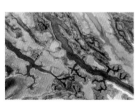

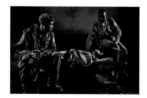

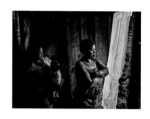

32–33
Pere Soler
SPAIN
pere.soler@outlook.com
www.peresoler.smugmug.com

46–51
Brent Stirton
SOUTH AFRICA
brentstirton@gmail.com
www.brentstirton.com
Agent
www.gettyimages.com

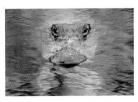

79
Mac Stone
USA
macstonephoto@gmail.com

84
Pekka Tuuri
FINLAND
pekka.tuuri@kolumbus.fi

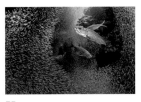

75
Mirko Zanni
SWITZERLAND
mailto@mirkozanni.com

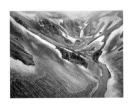

28–29
Hans Strand
SWEDEN
strandphoto@telia.com
www.hansstrand.com

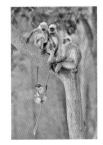

73
Thomas Vijayan
INDIA
descocanada@yahoo.com

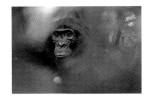

71
Christian Ziegler
GERMANY
zieglerphoto@yahoo.com

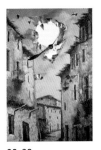

38–39
Juan Tapia
SPAIN
juanicotapia@hotmail.com
www.juantapiafotografia.com

82
Tony Wu
USA
tony@tony-wu.com